新台幣15840是台灣勞動基準法規定的最低工資。
雖然它是最低工資，但是經過多方扣款，對於在台灣的移工而言，它常常是「最高工資」。
NT 15840 is the minimum monthly salary for workers under the Labor Standard Law in Taiwan.
Though it's the minimum by law, after deductions
it's usually the maximum for migrant workers.

凝視驛鄉
VOYAGE
移工攝影集 15840

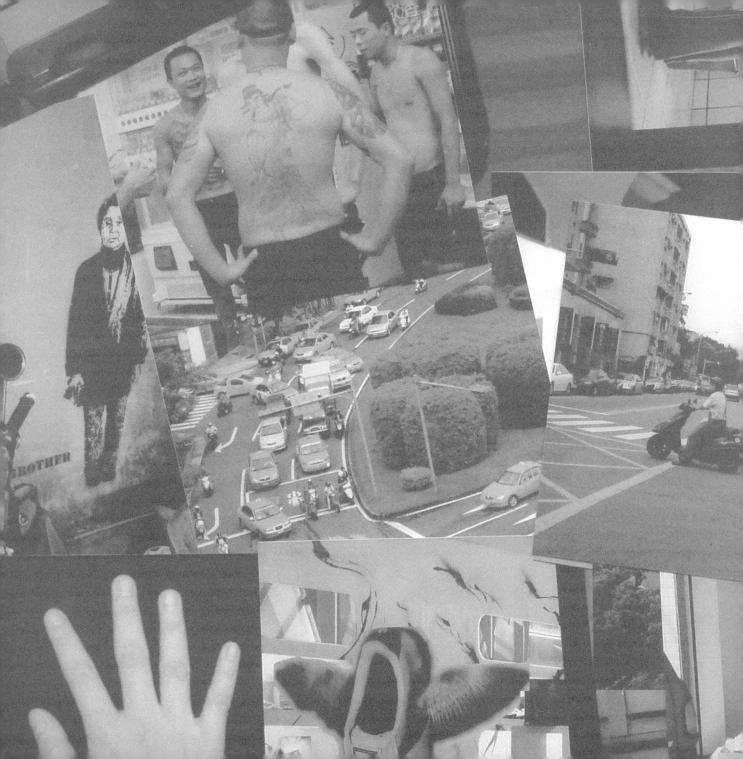

目錄

CONTENTS

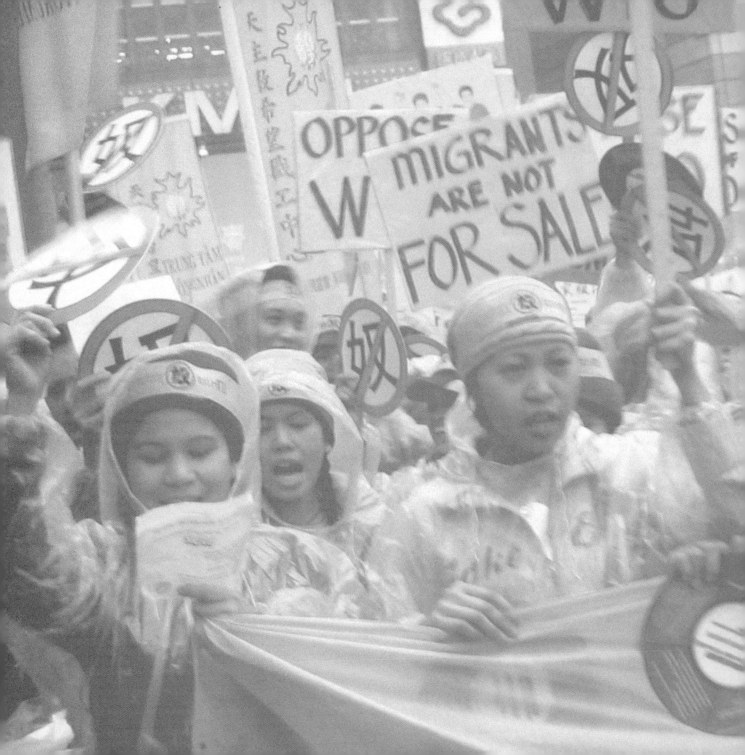

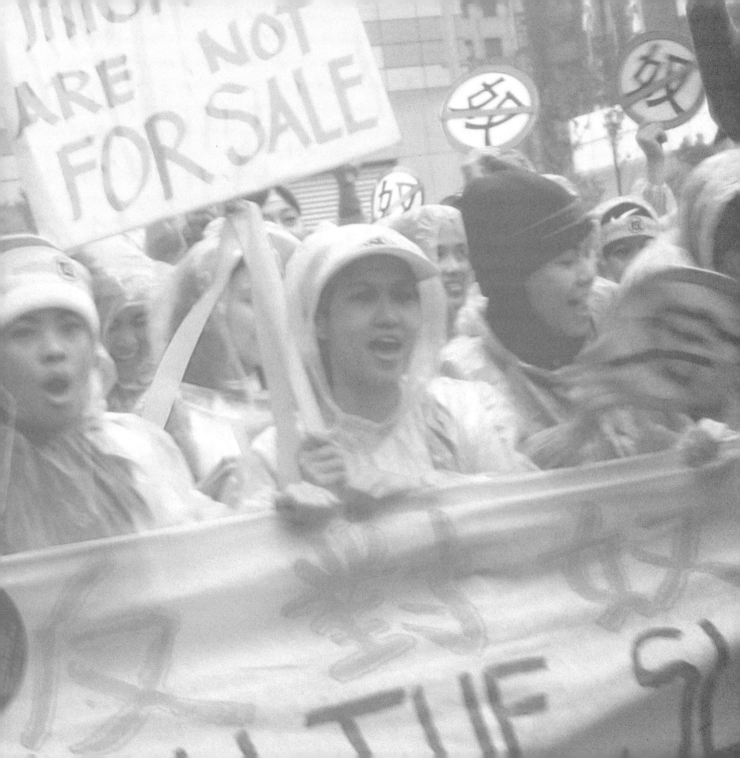

岩縫中開出的玫瑰

陳素香

自1991年台灣引進外籍勞工以來，因為整體政策對本地勞工衝擊太大，而引進外籍勞工的制度又千瘡百孔，做為勞工運動組織者的我們，多年來忙於應付本地勞工失業、勞動條件下降、工會組織弱化及外勞制度中的仲介剝削、非法遣返、奴化的勞動環境／條件、層出不窮的文化適應和衝突等等議題；已夠我們疲於奔命了。

然而，在這結構制度的層層壓制中，有如作家楊逵筆下的「壓不扁的玫瑰」，仍有許多堅韌的生命、情感、勇氣和夢想，盈溢於堅硬的岩縫中。因為貼近而有幸看見這些美麗的生命，是組織者的我們最豐碩無價的報酬，而我也始終認為這是勞工運動不同於激昂抗爭外表的，做為運動基底的深刻意義。

因此，儘管條件跟資源都很不夠，我們仍然竭盡所能的創造機會和嘗試，讓受制於結構制度的個體，得以撐開岩縫自由呼吸片刻，並讓其他人也看見她／他們較為完整的形貌；「移工攝影工作坊」即是我們的嘗試之一。

「移工攝影工作坊」共舉辦了二個梯次，學員以簡單的傻瓜相機或數位相機拍下她／他們身處驛鄉的觀察和感受，透過影像學習發聲，而成果即是本書呈現的。

弱勢者掙扎著發聲從來都是困難的，條件（人力及時間）、資源樣樣欠缺，若不是靠著一股想要發聲的慾望，以及朋友們義氣相挺，許多超負荷的工作是無法完成的。感謝吳靜如、江敬芳、陳慧如、許蕙如、陳秀蓮、張秉瑩等攝影工作坊的苦力群，以及許多默默支持我們的朋友們。雖然這些工作不是激昂澎拜的運動形式（有時簡直瑣碎到不行啊！），但是我相信我們是在工人運動的脈絡中，厚實它的底蘊內涵。

台灣國際勞工協會理事長

Roses Growing Between the Rocks

Susan Chen

Since 1991 when Taiwan started to import foreign laborers, the system of bringing in labor from abroad has been so problematic that it has had a major impact on local labor as a whole. Labor movement activists like us have for many years been busy with local labor issues like unemployment, degradation of working conditions and the weakening of union organizations. Meanwhile, we have had to deal with the problems that migrant workers face in Taiwan such as the exploitative broker system, illegal repatriation, slavery-like working environments, and culture-related adaptation and conflict issues. All these problems have kept us weighed down with work.

However, despite the multi-layered oppression caused by the structural system, the strong, emotions, courage and dreams of migrant workers still survive, resembling "the roses that cannot be flattened" that the late writer Yang Kuai wrote about. Their vitality is so strong that it pushes out from the hard rocky cracks. As organizers, we have the good fortune to see these beautiful lives up close——This is our greatest reward. This is very different from the excitement of protests, the surface of the labor movement that most people see. I have always believed that this is where the deeper, fundamental significance of the movement lies.

We did not have enough resources; nevertheless, we tried our best to create opportunities and space. We have tried to create opportunities, to let individuals caught within the system create some breathing space between the rocks, and to let them show a more complete image of themselves to the world. The Migrant Workers' Photo Workshop was one of our attempts.

We held two Photo Workshops for migrant workers. In the workshops, participants used their instamatic or digital cameras to photograph their observations and feelings in this foreign land. Through their images, they learned to speak. This album is the compilation of their performance.

It has always been difficult for social minorities to speak out. TIWA is short of everything—— human resources, time, financial support—— but if it were not for our desperate desire to help the migrant workers be heard we could never make it. We owe a great deal to many unnamed supportive friends and volunteers, and also to the "coolies" who carried so much of the workload: Wu Jing-Ru, Chiang Ching-Fang, Ellen Chen, Tracy Hsu, Chen Xiu-Lian and Chang Ping-Ying. Even though this activity was not carried out in a dramatic way, I believe that within the context of the labor movement in Taiwan, we have made an enriching contribution.

Chairperson of the Taiwan International Workers' Association

Translated by Wu Jia-Zhen

她們必須表述自己！

　　台灣國際勞工協會（TIWA）花了很大心力創辦移工攝影工作坊，並將兩期學員作品的成果展整理成攝影集，這是一項極為可敬、也極其動人的成績與實踐。主要以家庭幫傭為工作內容的創作者，將她們在工作空間裡的疲憊、寂寞、無助、與各種心情，以及對台灣社會／文化的體驗、觀察心得，直接而生動的顯影於作品中，成為一份非常有重量的影像創作與時代紀錄。

　　這份攝影紀錄，再一次改寫了馬克斯在《霧月十八》經常被引用的名句：「他們無法表述自己；他們必須被別人再現（或詮釋）。」法國大革命時代的農民缺乏組織，復被統治者弱智化，因此無法為自己發聲，只能依靠別人代言（例如他們的雇主）。在TIWA協助下逐漸培養自我賦權能力的移工們，透過攝影，與該協會形成的組織力量，將自己的生活情境與生命故事，第一手的、第一人稱的表述給這個只「使用」她們、卻大抵無視她們存在的雇主們與台灣社會。她們不但能夠、而且必須表述自己。

　　紀實性的攝影作品，究竟能否再現真實，一直是個辯證的問題。這雖然是複雜的議題，但若用簡單一些的方式檢驗，也多少可以回應它。例如：在真實世界裡，究竟誰再現誰？或者，攝影者能呈現哪些面向的真實與細節？影像的再現，最讓人詬病的，是將被攝者刻板化或他者化。例如，白人（或以白人的角度）的攝影裡刻板再現的非西方世界、中產階級眼裡的勞動階級、或本地人（「我們」）再現外勞（他們）的概念。階級／文化的本位主義，讓這些再現經常出現嚴重的扭曲。當移工們拿起相機，主體地敘述自己的狀態、情緒或思考時，雖然不表示她們的影像裡必然包含著更多的真實資料，但是這些材料與書寫，確實有助於我們對多重真實的認識，並帶來更大的反省。

　　移工攝影展裡的作品，整體而言對我是個衝擊。有些作品的訊息，我固然知道一些（例如她們的孤寂心情、與被雇主剝削的工作／生活條件等），但更多展現於圖文裡的她們的言說

能力與人的品質，是我不知道的。首先，她們工作條件普遍不佳甚至惡劣，許多攝影者或其同伴缺乏起碼的休假、或基本的尊重對待，但從作品中，我們看不到口出惡言者、連怨嘆的聲音都不很多。她們多半溫和平靜地陳述著心情與遭遇，甚至能夠尋找讓自己快樂的正面觀點；做為觀者的我們，在這些簡單的畫面與事實裡，只有感到更多的歉咎與心痛。

在本身已經辛苦的情境下，有些攝影者尚能同時看到本地人的辛勞（如檳榔西施、週日仍須工作的電工、必須自己做家事的鄰居老太太，等等），推己及人的同情著剝削她們勞力的這個社會裡其他值得關切的人們。更令人驚豔的是，一些移工的作品裡，反映了她們對於台灣社會觀察與對比不同文化經驗的敏銳度，以及使用影像符號做為隱喻的能力。

例如，Gracelyn G. Mosquera〈星期天的掃把〉一作，在簡潔漂亮的構圖裡，隱含的是一個週日可以休息的掃把、與許多在週日也無法休息之外勞的諷刺對比。在她的〈一百元與菲律賓國旗〉，更透過「萬國旗」裡（但實際上只有美、英、法、加、澳、日、韓等國的國旗）不可能找到菲律賓國旗的一個台北街頭景觀，再現了台灣在投射自己國際認同時崇拜與忽視的取捨對象。Ma. Belen A. Batabat一系列的台灣社會景觀，從捷運站裡的紅衫軍、Bbrother的街頭政治塗鴉、癌症患者的化療室，到西門町穿著西服外套、和善而尊嚴地賣鞋帶的老人，更是令人佩服的作品；其細膩準確的社會觀察能力，和對人的敏銳觸感，可以讓許多在大學校園裡生活貧血而致「缺乏題材」的攝影學生，感到汗顏。

移工們的攝影作品，不僅反映了她們集體的表述力與創造潛能，也在這些鏡像裡，自覺或無意地映照了台灣許多不堪的社會與文化內涵，無論是台灣雇主們對移工的剝削、違反人權，或台灣許多室內外空間的醜陋髒亂缺乏美感（卻常常自鳴得意地以為台灣列於已開發國家之林），抑或這種無視於自身醜陋的台灣井蛙性格，所愈積愈多的文化傲慢與卑劣品質。我要感謝這些移工、與協助她們的台灣國際勞工協會，在攝影中安靜地、準確地提供了我們一面面可以自省的鏡子，讓我們跟著移工們的鏡頭學習，重新看待自己的社會與文化。

文化評論者

They Must Represent Themselves !

Kuo Li-Hsin

The Taiwan International Workers' Association (TIWA) has put a lot of effort into setting up two photo workshops for migrant workers, and then putting together this photo album from the works of the participants. This is indeed an admirable and moving achievement. The photographers, who work mostly as domestic helpers, express their various emotions directly through their works. They show the feelings their working environment causes such as tiredness, loneliness and helplessness, as well as their observations of Taiwanese society and their cultural experiences. There is a significant weight in this visual document of contemporary Taiwanese society.

This compilation of photographic records rewrites the often quoted line from "The Eighteenth Brumaire of Louis Bonaparte" by Karl Marx, "They cannot represent themselves; they must be represented." At the time of the French Revolution, when farmers were not organized and were kept in a state of ignorance by the ruling class, they were not able to speak for themselves. They could only rely on other people, such as their employers, to speak for them. With TIWA's assistance, the migrant workers are empowered. Through photography, and TIWA's organizational assistance, they express first hand and in the first person their lives and stories and present themselves to the employers —— and the Taiwanese society as whole —— who only 'use' them but most of the time ignore their existence. They not only are able to but also have to represent themselves.

Whether documentary photographs can represent the truth is a long-debated question. It is a complicated issue. However, if we examine it in a simple manner, we can make some responses to the question. For example, in the real world, who represents whom, exactly? Or, which aspects of reality can the photographer reveal? It is particularly objectionable when images show the stereotyping or othering of the photographed person. For example, in the stereotyped image of the non-western

world taken by a white person (or from a white person's point of view), of the laboring class as seen by the middle class, or of 'foreign workers' (they) as viewed by local people (us). Egocentrism of class and culture usually seriously distorts these representations. When migrant workers take the cameras and describe their situations, emotions or thoughts, the images they create do not necessarily contain truer information. Nevertheless, these materials and descriptions do help us understand other aspects of multi-faceted truths, and thus will cause us to reflect on ourselves.

The images displayed in the migrant workers' photography exhibition, in general, had a strong impact on me. Although I was more or less aware of some facts depicted in the photographs and their captions, such as the workers' loneliness, the exploitation they face at work, and their harsh living conditions, what I did not know about was their ability to express themselves and the characteristics that they demonstrate in their pictures and words. For instance, their working conditions are usually not adequate, sometimes very awful. Many photographers and their friends do not get the minimum days-off required by law and do not receive even minimal respect or decent treatment. However, we do not see any abusive language in these works, not even much complaint. Most of them describe their feelings and situations. Sometimes they even find positive aspects of their conditions to make themselves happy. We, as viewers, can only feel more remorse and sorrow from these simple but poignant facts.

Despite the hardworking conditions which they endure, some of the photographers are still able to see the hardships of local Taiwanese people, such as the betel nut girls, the plumber who works on Sundays, or an old lady next-door who has to do the housework on her own. They put themselves in other people's shoes and sympathize with those who are also exploited in this society. The capability for observing Taiwanese society through comparisons of different cultural experiences and for using visual signs as metaphors shown in some of the works is simply amazing.

Take Gracelyn G. Mosquera's Sunday Broom for example. In this clean composition, it is implied that even a broom can take a break on Sunday, while ironically many migrant workers can not. In another work by her, One Hundred Dollars and the Filipino National Flag, she shows that among the 'international flags' (though actually one can only see flags of the U.S., the U.K., France, Canada, Australia, Japan,

and Korea) hanging above one of Taipei's streets, one cannot possibly find any Filipino flags. This work reflects how we Taiwanese people project our wishful identity through the selection and neglect of foreign flags. Ma. Belen Batabat also has a series of images about Taiwanese society: the red-shirt troops, the political graffiti by Bbrother, the chemotherapy room for cancer patients, and the shoelace-selling old man who dresses in a suit and works with dignity. With her keen observations of the society, and sensitivity to people, her works are so admirable that they put to shame many college photography students who have poor real life experiences and are 'lacking subjects to photograph'.

The photographs of these migrant workers not only show their collective abilities to express themselves and their potential to create, but also reflect, consciously or not, a lot of embarrassing aspects of Taiwanese society and culture. Be it the exploitation of migrant workers by Taiwanese employers, the violations of human rights, or the ugly, dirty environment in many Taiwanese indoor and outdoor spaces (which contrasts with our self-celebratory image of Taiwan as a developed country), Taiwan's society is shown to have the characteristics of a frog in the well who does not see its own shortness while accumulating cultural arrogance and depraved qualities. I have to thank these migrant workers and TIWA for providing such great photos as mirrors, through which we can see ourselves. Let us follow their cameras, and learn to look at our society and culture from a different point of view.

Critic of Photography and Media/Culture

Translated by Wu Jia-Zhen & Eric Scheihagen

當候鳥穿越藩籬……

張榮隆

　　一個偶然的機會行經台北車站，那是一個星期假日的傍晚，卻彷彿來到異國的國度。閃爍霓虹燈結合著異國的文字，整條街道喧鬧著聽不懂的語言，店家為了招呼絡繹不絕的客人，小板凳從店內排到了店外，音響也都播放著他們母國的語言。自從台灣開放引進外籍勞工彌補本地勞動力的不足，至今也十多年。這些從東南亞國家來到台灣的「外國人」隨之也帶入了一些異國文化。

　　全球資本市場的擴張，國與國之間經濟發展的差異，導致這群人四處移動，離鄉背井長時間的與家人分離。自己生活週遭也常會遇見他們，像是在朋友家幫傭的印尼籍幫傭，或是當年一起工作的泰籍勞工。這幾年來到台灣，過些年可能又會到香港或是新加坡——當初聽泰籍勞工朋友他們這樣說著。他們就像隨著全球資本移動的「候鳥」，從一個國度飛到另一個國度。

　　當了工傷協會的理事長後，再次接觸到他們是2004年9月份。三名越南勞工遭受職業災害，斷手斷腳在勞委會門前痛訴台灣的勞動人權，以及台灣的雇主和仲介如何壓榨這群來自異鄉的勞動者。

　　隨著台灣經濟的起伏，他們也背負著政治經濟上的罪名。就像每當節慶的時候政府單位都會辦些活動，表彰這群來自他鄉的勞動者，說他們對台灣的經濟建設有多大貢獻；但更多時候政治人物以及政府單位，將台灣的政策錯誤所引發的失業、治安敗壞問題加諸在他們身上，形容他們像禿鷹、蝗蟲一般侵蝕了本地經濟而將財產匯回母國，造成台灣資本大量流出，排擠了本土勞工的工作權利。

　　國家的強弱不應該只是定義在經濟上的發展。當大多數的台灣人對這群來自異鄉的過客，用簡單的符號「勞力」、「金錢」等框架在他們身上，便看不到他們除了工作以外的另一

面。攝影是一種影像紀錄。這次台灣國際勞工協會（TIWA）帶領他們利用影像紀錄他們心目中台灣這塊土地，少了強勢本土文化的主導，多了外勞朋友們的觀察和思考。

藝術是一種可以穿越藩籬的表現。一件攝影作品的完成，是經過攝影者本身的觀察。透過相機的鏡頭捕捉那瞬間的影像，不論作品的成敗跟技術的好壞，當按下快門的那一剎那已經將攝影者心靈情境凍結在那瞬間，就待旁人如何去理解體會。

一個期待讓人尊重的國家，本應該先學習看待另一種文化。和來自其他國家的人民相互理解、包容、尊重，藉由另一種角度來看台灣這片土地精采的多元文化。讓照片裡真實的影像情感引領著我們自己成長學習、認真且嚴肅的看待目前資本主義下扭曲的世界。

工作傷害受害人協會現任理事、前任理事長

When Flying Migrants Break through the Hedges......

Chang Jung-Lung

It was a weekend evening. I happened to pass by the Taipei Train Station, and it seemed that I had run into another country. The glittering neon lights reflected exotic letters and the whole street was filled with loud yet strange speech. To accommodate the endless stream of customers, store owners arranged stools from the inside to the outside. Songs playing from the speakers were sung in their mother tongnes. It has been more than ten years since Taiwan began to introduce foreign workers to make up the insufficiency of local workers. With these "foreigners" from Southeast Asia were exotic cultures brought in.

The expansion of the global capitalist market and the differentiation of each country's economical development make people migrate worldwide, leaving their families and hometowns for a long time. I encounter these people often in my daily life——for example, the Indonesian domestic worker in one of my friends' family, and the Thai workers working together with me some years ago. Some Thai friends told me that though currently they are staying here in Taiwan, the next moment they may be in Hong Kong or Singapore. They are just like migratory birds, flying from country to country along with the flow of global capital.

After I was elected the director general of the Taiwan Association for Victims of Occupational Injuries, I had the chance to connect with them again in September 2004 when three Vietnamese workers suffered from occupational injuries. Showing their broken limbs in front of the Council of Labor Affairs, they criticized in tears Taiwan's lack of labor rights and accused Taiwanese employers and brokers of severely exploiting workers from overseas.

11

The migrant worker has also been scapegoated politically and economically with Taiwan's economic boom and recession. Occasionally the government holds activities on holidays to praise the great contributions of foreign workers to economic development. Most of the time, however, the politicians and the government blame foreign workers for the consequences of their own wrongful policies, such as unemployment and the decline of public security. They are described as condors or locusts which rob properties and send the money back to their motherlands, causing the tremendous outflow of Taiwanese capital and reducing local labor's opportunities.

The strength of a country should not be defined only by its economic development. When most Taiwanese portray these guests from foreign countries in terms of simplified symbols such as "workforce" or "money", they may overlook other aspects of their lives beside work. Photography is a record of images. When the Taiwan International Workers' Association (TIWA) organized this photo workshop and encouraged the participants to represent this island from their own perspectives, migrant workers were able to present their observations and thoughts without being led by the dominant local culture.

Art is a representational form capable of transcending boundaries. A photographic work is, after the photographer's observation, an immediate image captured by the lens. Whether the work is successful or whether the techniques are good or not, when the camera shutter is pressed the photographer's soul is already frozen in that instant. It waits there only for other peoples' appreciation and reflection.

If a country expects respect from others, it first has to learn to respect other cultures. We have to learn how to understand, tolerate, and respect people from other lands and renew our perspective on the diverse, colorful cultures in Taiwan. Let the

sincere and sentimental images inside the photos lead us to empower ourselves on the one hand, and on the other to take a serious look at this world twisted by capitalism again.

Board member and former president of TAVOI
(Taiwan Association for Victims of Occupational Injuries)

Translated by Ping-Ying Chang

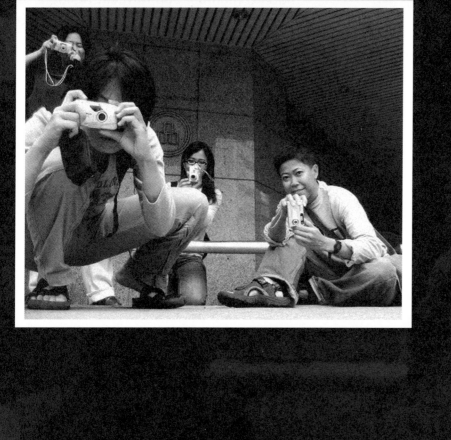

完整的人
——移工攝影工作坊的組織經驗

吳靜如

台灣國際勞工協會在移工運動的相關事務中，小從法律諮詢、個案服務、解決爭議，大到政策抗爭、國際串連，無一不是希望這群因為資本主義的全球性擴張而必須越洋漂流、打工生存的勞工，能夠活得像人；雖然當代社會離實質民主／人民作主尚遠，但，至少必須逐漸地平等。這是我們基本的信念。

在日常生活中互相看見

因此，除了挑戰移工政策和制度對於這群底層勞工的壓迫外、除了爭取勞工在勞動與生活的基本保障外，我們更認為，要能夠達到具有實質平等與民主的文明社會，由上而下的制訂法律／政策固然重要，但更重要的是，在日常生活中學習相互地看見、了解與尊重。

所以，就算在窘困的條件下，我們也持續地努力，希望能創造出移工群體和台灣社會的對話空間。不但要讓社會清楚地看見移工，也要讓移工直接地面對台灣社會。過往，我們以詩文創作、歌舞展演、肢體培訓、故事敘述、紀錄片拍攝……等對內組織、對外發聲的文化媒介，讓移工的各種樣貌真實出現，形成社會對話的基本素材。

移工攝影工作坊也是在這個文化戰線脈絡中的另一種嘗試——我們試著降低語言／文字的阻礙，用移工們熟悉的方式和工具，讓他們在長期被環境形塑成習慣沈默的狀況下，逐漸的表達感受、說出感覺。其實有勇氣與膽識飄洋過海的移駐勞工，並非愚昧無知或低賤遲鈍，他／她們一樣有敏銳的觀察力和感性的心靈；但是因為她／他們所處的社會位置以及壓制的社會結構，使他／她們難以說出作為一個完整的人、作為有能力飄洋過海的勞工、有能力面對辛苦的工作條件和疏離的生活環境的人，對於這一切的感受和看法，並發展出正視自己、移工主體的觀點。

我們從在攝影機前被拍攝的移工的照片，作為討論的開始。

照片背後的故事

幫小孩穿衣服的移工、扶著阿媽從輪椅上站起來的移工、面對整潔工作環境工作著的廠工、吃著喝著唱著跳著的移工……在看完一連串被拍攝者的移工圖片後，大家開始討論看到了什麼、想到了什麼。有人說，「那個幫小孩穿衣服的移工，看起來好像很累，那兩個小孩看起來很皮……照顧小孩很不容易，隨時都得注意她們……」，有人說「扶著阿媽的移工跟阿媽好像很親近……我的阿媽常常會罵我，我怎麼做都不對……」，有人說「那個在乾淨的廠房裡工作的廠工，其實是很累的，因為我做過工廠的工作，很無聊、很單調，而且，一整天做下來，有時候連上廁所、喝水的時間都沒有。她的工作環境雖然看來不錯，其實是很累的……」她們說著的，其實是照片背後的故事，是她們共同經驗的連結。

「在台灣的移工，大部分的時候很辛苦，是嗎？」大家頻頻點頭。「可是，為什麼這些移工被拍的照片裡，很少看到生氣、難過、擔心、寂寞呢？」學員們進入專注的安靜。再拿起相機時，她們知道了在相機前後的差異。

「出作業」是苦力群最傷腦筋的事

我們幾個苦力，一個是常常為受虐兒童操勞煩心的刻苦社工員，一個曾經因為仲介在大庭廣眾下對移工大聲吼叫而落淚、現在是工會第一線工作者，一個是專業美學出身、佳作頻頻的歸國藝術家，我咧，則是創意不足的中年移工組織者。

面對這群多是女性、多是家庭類勞工、休假不多、工作和生活範圍侷限性高的學員，因為準備教材、整理學員作業、交換上課的心得、討論下次的作業題目，我們常常從白天熬到深夜。

譬如說，因為考慮學員們非常有限的時間和空間，希望在第一次給的作業是他們熟悉且直接的主題，所以，在苦力群數個小時的討論之後——第一次的作業是「食物和廚房」。

學員們交回的作業，很多是室內的場景、很多是排放整齊的餐桌和食物，也有學員立刻交出了構圖、色彩都令人驚豔的作品，當然也有學員交出連自己都懊惱的模糊不清的失焦照

片。每次上課，討論學員們的作業都佔著最重要的份量。討論，作為攝影工作坊的重點，不但是攝影技術層次上的心得交換，更是學員和苦力們相互推動進一步分享、刺激思考的重要過程。

圖說 (caption) 與照片的關係

透過投影機，牆上打出一張有著骯髒瓦斯爐的照片，圖說上簡單寫著「我們在雇主提供的非常舊的瓦斯爐上煮食」。

「為什麼要拍這個呢？」

「因為我有很多朋友，他們的雇主不給他們煮東西。有時候想吃菲律賓菜，都很難吃到。我們可以自己煮，雖然有時候會擔心這個爐子是不是會爆炸（全班大笑），但是我還是很感謝我們老闆，可以讓我們自己煮東西。」

「為什麼不把你說的寫上去呢？」

「我不知道可以這樣寫……」Alice不好意思的說。後來，在學員們交的作業裡，圖說和相片的關係，常常令苦力群們驚訝於這些學員的觀察和領悟。

一支插在門上的鑰匙、一片習以為常的旗海、一個毫不起眼的客廳角落、一隻自拍的手掌、一張少了一副碗筷的餐桌、一棟現代化的帷幕大樓……我們看到了學員們開始拍感受，開始拍擔心、開始拍害怕，也開始拍開心、開始拍落寞，同時開始提問、開始幽默。

互相成長的新視界

我們的學員們確實展現了勇氣。不只透過拍攝、面對自己的情緒需要勇氣；「拍攝」這個動作本身，對掌握鏡頭的移工來說，更需要面對被拍攝對象的勇氣。工作坊初期，學員們從遠遠地、帶著距離的拍攝，到鼓起勇氣與被拍攝者說話，短短的時間內，非常大的躍進。學員Ellen說，「我怕警察，可是，我很想拍警車，因為台灣的警車都一樣。在菲律賓警車什麼樣子都有。那天，我鼓起勇氣去拍……」；中文很溜的Vangie說，「我跟賣冰淇淋的阿伯說我要拍他，他就面對我笑，給我拍……」我們看到學員們拍攝的手腳穩了，心也穩了。

對於我們苦力們來說，這也是一個學習啟動的過程。苦力Tracy在攝影工作坊中，透過覷腆的英文和學員們互動，並對照著她工作上必須面對的本地勞工；當「自我介紹」的作業題目被討論出來時，苦力Ellen戒慎恐懼地自願加入拍攝的行列，感受到「要在大家面前講自己的生活，是需要勇氣的⋯⋯」

　　攝影工作坊將剛回國、沒接觸過台灣移工的苦力小江，從在他國的弱勢移駐學生身份，轉為面對在台移駐勞工的相對強勢。透過攝影工作坊，他開始了解在台移工面對的困難。至於我，透過攝影工作坊的討論、苦力群的腦力激盪與課程檢討，及和TIWA成員的討論，一次又一次地重新面對移工這個議題，相對於討論和照片中呈現的開放和理解，常常看到的是自己過於憤怒和焦慮的情緒⋯⋯

　　我們這群被重新教育的苦力們，藉著工作坊、討論、聆聽，在平凡常見的移工問題背後，重新理解到身在他鄉異國所需要的的種種應對勇氣和能力。

培力（empowerment），從來都是疊步前進的

　　如果全世界小孩的妄想都是吃麥當勞、穿耐吉、到迪士尼，所謂的多元文化可以從何說起？藉著移工攝影工作坊，我們企圖透過勞動文化的角度，從移工的領域，帶出不僅僅是食衣住行異國情趣的多元，更是生活/勞動/文化的多元。工作坊的進行，開展了移工和苦力們新的認識；而攝影集是靠著TIWA的組織者向所有關心移工議題的社團、個人募捐助印，才得以出版。文化戰線，集結邊緣的聲音，向主流界線挑戰；而弱勢培力，也從來就是這樣疊步前進。

台灣國際勞工協會總幹事

Fully Human
—— the experience of organizing the migrant workers' photography workshop

Wu Jing-Ru

The work that TIWA does within the migrant workers' movement ranges from legal counseling, casework service, and negotiating labor disputes, to protesting for policy change and networking with international NGOs. As capitalism spreads globally, these workers must cross oceans to make their living. Our only hope is that they can live like human beings. Contemporary society is still far from realizing true democracy, but equality must come, even if the process is slow. This is our basic belief.

Seeing each other within daily life

Aside from challenging how Taiwan's migrant worker policies and system oppress these lowest level workers, aside from fighting for workers' basic protections in working and living conditions, we also believe that if we want to create a truly egalitarian and democratic society, legislation and policy from the top down is certainly important, but even more important is learning how to see each other, understand each other, and respect each other in our daily lives.

Therefore, we continue working hard despite difficult conditions, in the hope of creating a space for dialogue between migrant workers and Taiwanese society. Not only do we want society to see migrant workers clearly we also want to let the migrant workers directly face Taiwanese society. We use cultural media such as poetry, dance performance, movement training, story-telling, and documentary film, to encourage the workers to get involved in labor organizing and to help them speak out, to make different aspects of their real lives visible and thus create some

19

basic materials for cross-cultural dialogue.

The migrants' photography workshop is another experiment among our cultural strategies. We tried to lower language barriers by using methods and tools that migrant workers are already familiar with. The habit of silence builds up over time in their environment, and we want to help them to gradually begin to express their feelings and impressions. Workers who are daring enough to live and work over-seas are neither ignorant nor stupid; they also have keen observational skills and sensitive spirits. These workers are complete human beings, they are capable of crossing oceans, of dealing with the difficult working conditions and the isolation of living in a strange environment. But because they are pressed into the lowest ranks of the social structure, it is difficult for them to articulate their unique point of view as migrant workers and to develop their own subjectivities.

We start the workshops by discussing photographs of migrant workers taken by other people.

The stories behind the photographs

A migrant worker helping children get dressed, a migrant worker helping a grand-mother stand up from her wheelchair, someone working a machine on an immacu-lately clean factory floor, migrant workers eating, drinking, singing, dancing... After looking at a series of photos where migrant workers are in front of the camera, everyone started to talk about what they saw, and what it made them think about. Someone said, "That migrant worker helping the kids get dressed, she looks really tired. I bet those children are really naughty...taking care of kids isn't easy, you have to be paying attention to them all the time..." Someone said, "That migrant worker and the grandmother she's helping up, they seem so intimate...the 'Granny' I take care of often yells at me, nothing I do for her is ever right..." Someone said, "That factory worker in that clean factory, actually she's really exhausted. I've done that kind of factory work, it's really boring and repetitive. And you have to do it all

day, sometimes you don't even get time to go to the bathroom or take a drink of water. Even though her work environment looks all right, she's really very tired…" They were telling the stories behind the photographs, and finding out their common experiences in the process.

"The migrant workers in Taiwan, most of the time it's really hard for them, isn't it?" Everyone nodded their heads. "But how come in these pictures we rarely see them looking angry, or sad, or worried, or lonely?" The workshop members all became quiet and thoughtful. When they picked up their cameras again, they understood the difference between being in front of the camera and being behind it.

Coming up with assignments was the hardest task for the workshop facilitators

There are four of us on the team that facilitates the photography workshops. We call ourselves the "coolies" because our work is to help the migrant workers build their own roads. One of us is a social worker concerned with abused children. One of us once wept with rage when a broker rudely dismissed a migrant worker in public. Now she's a front-line worker for a trade union. One of us is a professional artist, just returned from studying overseas. And me, I'm a not very creative middle-aged labor organizer.

Our workshop members were mostly women, mostly domestic workers with little time off. The space of their work and lives was severely limited. We coolies often spent all day and long into the night preparing teaching materials, organizing the members' homework, discussing how the last class went and coming up with the assignment for the next class.

For instance, because we knew the members had very limited time and space, we wanted to make the theme for their first assignment something direct and familiar. After our team discussed it for a few hours, we picked the first theme: food and kitchens.

A lot of the photos that the members turned in showed interior scenes. A lot showed neatly laid out tables with food. Some of the members turned in photos whose framing and colors were surprisingly beautiful. And of course some members turned in fuzzy missed shots. Every time we held class, we spent the most time going over the members' photos. Discussion was the most important part of the workshop, not only sharing what we'd learned about technique, but deepening the interaction between the coolies and the members, and energizing our thinking process.

The relationship between photo and caption

A photograph of a filthy stove is projected on the wall. The caption says simply, "We cook on the very old stove provided by our employer."

"Why did you photograph this?"

"Because I have a lot of friends whose employers don't let them cook. Sometimes they want to eat Philippino food, but it's very hard to get. We can cook for ourselves. Even though we're sometimes afraid that the stove might blow up [everyone in the workshop laughed], we're really grateful to our boss, because he lets us cook."

"Why didn't you write what you just said?"

"I didn't know you could write that way..." Alice said shyly. After that discussion, the captions the members wrote for their photographs often surprised us with their observation and insight.

A key inserted in a door, rows of familiar flags, an unremarkable corner of a living room, the palm of the photographer's own hand, a set table with one bowl and one set of chopsticks missing, a modern International-style building...we watched the members begin to photograph their feelings, their worries, their fears, their happiness, their loneliness. At the same time they started to ask critical questions, and to

reveal their sense of humor.

New worldviews grow out of interaction

Our members really showed courage. The very act of "taking pictures" was intimidating for most migrant workers. Not only did they have to face their own emotions through their photography, they needed even more courage to face the subjects they photographed. At the beginning of the workshop, the members took their photographs from far away, maintaining distance from their subjects. But then they worked up the courage to speak to the people they were photographing – a big step in a short time. One member, Ellen, said, "I'm afraid of cops, but I really wanted to take a picture of a police car, because in Taiwan the police cars are all alike. In the Philippines, there are all different kinds of police cars. One day, I screwed up my courage to take a picture…" Vangie, who speaks fluent Chinese, said, "I told the uncle selling ice cream I wanted to take his picture. He just smiled at me, and let me take it…" We saw that as the members became more comfortable with the camera, they became more comfortable with other people as well.

For us coolies too, this was a learning process. Coolie Tracy used her halting English to interact with the migrant workers in the workshop, and thought about the local workers she interacted with in her job at the union. When we discussed the assignment theme "Self-Introduction," Coolie Ellen overcame her fears and decided to show her own photographs in class. She realized, "It really takes courage to talk about your life in front of everyone…"

Coolie Little Chiang had just come back from overseas and hadn't met any migrant workers in Taiwan before. She had been a disenfranchised foreign student in another country, but she found herself in the superior position in relation to the migrant workers in her home country. Through the workshop, she started to understand the problems that migrant workers face in Taiwan. As for me (Coolie Jingru), through the photography workshop discussions, brainstorming with the other coo-

lies, and discussing the workshop with my coworkers in TIWA, I had to study the issues of migrant workers from one new angle after another. The photographs and discussions often made me see my own anger and anxieties...

The workshop, our discussions, and listening to the workers re-educated us; we "coolies" gained a new understanding of the migrant workers' common problems, and just how much courage and ability it takes to live in an unfamiliar country.

Empowerment is a dialectic process

If all the children in the world want to eat McDonald's, wear Nike, and go to Disney World, then where can we find cultural diversity? In the migrant workers' photography workshop, we tried to find a kind of diversity beyond the exoticism of food, clothing, and travel; through the migrant workers' cultural perspective we tried to open up a diversity of life, work, and culture. The workshop created a new kind of mutual recognition between the migrant workers and organizers. The publication of this album of migrant workers' photographic expressions was made possible by support from a variety of people and groups. TIWA organizers relied on help from of all the NGOs concerned with migrant workers, as well as individual donors. Cultural struggle brings together the voices of marginalized people to challenge the mainstream; minority empowerment always develops in this way, in incremental steps.

Executive Director of Taiwan International Workers' Association

Translated by Teri Silvio

框外的真實

江敬芳

「這些影像究竟有多真實？」不只一次我接收到觀者透露出這樣的疑慮。我無意代替創作者回應，但身為工作團隊的一員，我可以從苦力的角度講述一些我所知道的——影像框外的「真實」。

打從一開始，TIWA的「移工攝影工作坊」就是定位分明的勞教課程，而非學院藝術教育或是民間沙龍攝影進修班，其重心是放在學員作為移工身份的自我觀照和與社會的互動觀察。因此，無論從教材內容、上課方式或是作品的性質來看，整個經驗其實更接近「影像抒情」和「發聲練習」，本質上與「紀實攝影」並不完全相同。

半年為一期的課程不長不短：在基礎技術的訓練上，攝影可以很快上手；構圖美學的部份則各憑本事，有天份的自然就出線；最挑戰的，卻是在如何明確表達「主體」的立場。影像也好文字也罷，一次又一次我們問學員：你想要說的是什麼？你希望如何表達？作業繳來了，幾百張影像圖說當中不乏構圖優美觀察細膩的作品，唯以第一人稱為表達主體的聲音卻大量缺席。幾次課上下來我才慢慢悟到，長時間處於以達到他人要求為行事準則狀態下的人，要舒坦自在的說出：「我看到」、「我覺得」或「我認為」、「我想要」竟不是那麼的理所當然。這與我過去在學院裡的經驗正好相反。學院裡的學生交作品討論時，往往不自覺的把「我」放在作品的先行，不知不覺中養成主體的過度放大並反映在生活態度上。在台灣，在移工攝影班，「我」這個主體明確的概念是經過時時提醒與反覆練習來的。

拍照並非純粹的攝像活動，尤其牽涉到他人的「家」與「家人」這樣私密的場景。當個人的工作場域與他人的私生活領域高度重疊時，勞動現場的再現難免越界，一不小心就闖入屬於影像倫理範疇的禁地，這對學員與苦力都是一道難題。創作的客觀條件人人不同。沒有固定休假的，先在腦子裡構想作業主題，思考著如何拍、找什麼題材等等先寫下來，等待機會再循著自己的筆記去拍攝；與雇主約法三章不拍家裡不拍小孩的，就只能出外景；沒有機會

出門的，把物件擺在床上或茶几，拍起靜物；在工廠勞動的，搶片刻的休息時間對著窗外取景。因為有心，每個人皆發展出自己一套應對的辦法，甚至買菜接小孩上下學往返醫院家裡的路上，都成為觀察快照即興獵鏡的最佳機會。

學員們各展長才，苦力們可也不輕鬆。工作坊有抽象的課程大綱但沒有太多預設，苦力與學員一同邊走邊學。出外人敏感細膩，察言觀色間摸索著如何的切入、書寫，較容易得到我們的肯定並在同儕間引起認同與迴響，難免受影響。當我們小心翼翼的在「我們想知道什麼」與「他們想拍／說些什麼」之間斡旋，如何引導實際有效的討論且不至於過度介入甚至淪為情緒煽動，又是另一個很細緻的部份，拿捏之間總擔心顧此失彼，如何設計出既精準又具最大發揮空間的作業主題，就成為苦力們的終極挑戰。

視覺影像能引發多元的詮釋，文字又比無聲的影像更具發言與釐清脈絡的功能。選擇以「圖文互動」為工作坊創作的表述形式，讓擅長以文字或影像思考的個人都能夠找到適合自己的發揮空間，也使作品得以推衍到評論與敘事的層次，不至於侷限在攝影媒材本身的當下即時性和單點透視的觀點。

照片並不見得能與事實畫上等號。但我更喜歡這樣的說法：「一個單一事件必定有多重真相。」這也是我當初參與執行「移工攝影工作坊」的最大動機：即是在一向握有絕對發言權的在地多數與主流媒體所呈現的「事實」之外，另闢一個發聲管道，換個角度換人說故事。至於說故事的人選擇如何說，說的是 fiction 還是 fact 就不是最重要的了。我比較在意的是──有這樣的機會，輪到他們說，以他們的方式表達。

移工攝影班苦力

Truth Outside the Frame

Chiang Ching-Fang

"How real are these images?" More than once I detected this kind of doubt from the viewers. I don't intend to respond for the photographers; however, as a member of the working team, I can give an account of what I know, from a "coolie's" point of view——the "truth" outside the pictorial frame.

From the beginning, TIWA's "Migrant Workers' Photography Workshop" was categorized clearly as a labor education program, not as academic art education or laypeople's photo club lessons. Student members' self-reflection as migrant workers and their interaction with and observation about Taiwanese society are the main focus of this workshop. Therefore, in terms of pedagogy, teaching materials, or the work of art as a whole, the whole experience is closer to "self-expression," which may or may not be seen as documentary photography.

A six-month term is neither long nor short. The basic skills of photography can be quickly picked up while the aesthetic part depends largely on individual talent. The most challenging part lies in "how to express oneself subjectively," either through images or words. Again and again we asked the students: "What do you want to say?" and "how do you wish to go about saying it?" Among hundreds of images from a take-home assignment, we did not lack for pictures with beautiful composition or sophisticated observation; what we found was the conspicuous absence of an "I" as the first-person viewpoint expressing the voice of the subject. Gradually I realized it was not easy to say "I" (i.e. "I see, I feel, I think, or I want...") given that the principle of their job is mainly to cater to other people's every need. This is the

opposite of my past experience in the academy: in discussing their works, students in the academy tend to unconsciously foreground the "I" without further awareness. This hypertrophy of the "I" reflects perfectly on aspects of their life and their living attitude. In the Migrant Workers' Photography Workshop, however, the concept of the "I" was gradually regained through frequent practice.

For them, taking pictures is not simply an act of image-making, given that the act itself involves the privacy of other people's domiciles and their family members. When one's working place is highly overlaid with other people's private space, to represent the laboring scene becomes inevitably an act of transgression. Unwittingly, it is easily to slip into the taboo area bounded by photography ethics, which is a thorny issue both for the workshop students and us coolies. The conditions provided for photographic creation differ from person to person: for those who don't have days-off, they pre-conceive themes for their assignments and wait for opportunities to take pictures following their written notes; for those who make a rule with their employers about not photographing the kids or inside the house, they can only do outdoor shootings; for those who cannot go out, they photograph still-lifes by placing objects on beds or side tables; for factory workers, they take pictures in their scarce break time; for those who shuttle between market, school, and hospital, they take pictures on their way. Because they care about the assignments and put their minds to them, they evolve different ways of seizing chances to take pictures.

For us coolies, it is not easy either. The workshop has abstract course outlines but not concrete guidelines. Like the workshop students, we also learn along the way. Away from home, the migrant workers are particularly sensitive and attentive to people's requests; easily, they find ways to please us and to win recognition from their classmates, at the expense of their own subjectivity. In other words, we need to maneuver carefully between "what we want to know" and "what they want to say." How to maintain the effective discussions without plunging into an emotional provocation is another tricky part; it is very hard to take care of both sides at once. Therefore, the ultimate challenge for us coolies is to design assignments that can

not only be precise but full of expressive potential as well.

Visual images invite multiple interpretations, while words specify and give contextual guidance. Choosing "photo-text interaction" as the workshop's expressive format, we aim to provide students with expanded opportunities to create. Whether they are a word person or an image person, here they can always find a suitable form to express themselves. Moreover, textual description can give a photo layers, expand the photo beyond the limit of temporality or a restricted, single-point perspective.

Of course photographs are not really equal to truth. But I like this saying more: "There can be one event and several realities." This is what motivated me to participate in this workshop——namely, in the so-called "truth" narrated or presented by the local majority and mainstream media, we need to open another channel, to have a different person telling her/his story. As to how the storytellers choose to tell the stories, or if the stories they narrate are fictional or factual, it is not important. What is important is that now it's their turn, that they have this chance to tell their side of the stories and to express themselves in their own ways.

Coolie of Photography Workshop

講自己‧聽別人
——鏡頭後的故事

陳慧如

　　還記得第一堂課，大家在觀看一位台灣攝影師拍攝的系列外勞相片時，針對一張家庭幫傭替孩子換褲子的照片，學員你一言我一句熱絡討論、回應，談自己看照片的感覺，或者回應自己的工作內容及經驗，包括親生孩子在菲律賓，卻去到外國照顧別人的小孩……課堂好像是一個支持性團體，大家說出的經驗很貼近也很真實。

　　後續又加入種族跟階級、勞動現場等等主題，大家自由討論，依舊希望透過上課過程，可以相互激發或讓學員多看到一些什麼。之後的回家作業，學員拍出來的東西更令苦力團隊驚訝，如Alice拍自己在工廠的便當菜色，用簡單的文字去形容講自己，很可愛也很有力量；Glorette的照片色彩鮮明，她發現自己是一個天生的攝影師；Blessie對自己工作場域的高敏感度，每一張照片的主題都相當聚焦……總之，學員拍攝出的照片加上自己的故事說明就是有獨特性，透過學員拍的照片發現到，原來簡單的一張照片可以帶出大家這麼多故事，講授課堂主題的照片討論時間，讓大家開始講自己也聽別人。

　　學員的進步及認真程度也是令苦力團隊感動與驚嘆不已！Bell的作品中，與對象的距離可以看出她對被拍攝主題的擔心，經過課堂的討論後，Bell展現對於環境的強烈感受及敏銳度，拍出了與第一次完全截然不同的作業；還有Ellen和Charisse對課堂的投入，認真的在圖說裡書寫自身的經驗。

　　一開始的單純想法是，覺得可以透過這個工作坊，增加移工對環境的敏感度，透過表達自我的感受，用照片去述說自己的故事。至於我與Tracy也跟著做中學，不僅學到拍照的技巧、基礎的美學及顏色概念，重要的是還可以分享學員所拍出每一張照片，更清楚的感受到、也看見移工們的獨特性及他們如何看待自己與台灣關聯性的故事。

<div style="text-align:right">移工攝影班苦力</div>

I Talked and I Listened
——stories behind the lens

Ellen Chen

The photo workshop's first class was focused on a series of photos of migrant workers taken by a Taiwanese photographer. And when a picture was presented showing how one caregiver changed a baby, I remember, an enthusiastic discussion was promptly raised. Workshop members shared their feelings about this photo, their similar working experiences, their circumstance of working overseas, taking care of others' children while leaving theirs in Philippines, and so on. It was like a support group, where everyone talked in an authentic and intimate manner.

In following classes, issues such as racism, classism, and labor practices were introduced in succession. Still, the same mutual stimulation and broadened views were repeatedly fostered within the unrestrained discussions. Another surprise to us, the "coolie" instructors, was the work created by the members as their submitted homework. For example, how Alice photographed her factory lunchbox and how she depicted herself are really lovely and powerful; Glorette, with her flamboyant works, came to believe herself to be a natural photographer, with a high sensitivity to her labor practices, Blessie's photos are extremely in focus. The distinctiveness of their photos, along with the narratives attached to them, made me realize how many stories one single picture can invoke. It was during these photo discussion sessions that everyone started to talk and listen.

The extent to which the members made instant progress and earnestly involved themselves indeed touched and amazed us coolies. For example, after a collective discussion about Bell's concerns over the photographed objects, which were rep-

resented by her long shooting distance, in the next class she brought along pieces with absolutely different perspectives. Ellen and Charisse, in another case, dedicated themselves to contributing to class discussion as well as carefully incorporating their experiences into the captions.

Our preliminary idea for this workshop was to enrich the migrant workers' sensitivity to their social settings and to encourage them to express feelings by way of photographing. Joining the whole process, Tracy and I, among other coolies, not only learned techniques, aesthetic and chromatic concepts of photography, but also, more importantly, shared every picture with all the members. In them, we clearly perceive migrant laborers' particularity and their viewpoints on overseas living in Taiwan.

<div align="right">Coolie of Photography Workshop</div>

Translated by Tseng Han-Sheng

大家共同完成的事

在工作坊中，我選擇負責一些比較事務性的工作，也讓自己相對處於比較邊緣的位子（這也暴露我自己的問題），再加上英文不好，不大敢開口和外勞聊天，又喪失一些深入瞭解的機會。但整個過程中，不只是學員在學習，我參與其中，常發覺到：「哇！原來可以這樣取景」、「原來她們是這樣在思考這些工作」、「原來她們對於XX事物有這樣的感想」……，太多太多意想不到的收穫。

我自己畢業於勞工系，曾任職於市政府的外勞「管理」部門，離職後一度以為自己一輩子不會再踏入勞工領域，後來進入了基層工會工作。在移工攝影工作坊的參與過程中，我有時會想若是我們工會的會員來當攝影師，不知道會拍出什麼樣的故事？也許，就從我自己開始，來拍一個在工會工作的連環照，一定很有意思！

坦白說，我覺得自己在這個團隊沒什麼特殊貢獻，純粹是想支持靜如的發想，所以拉著Ellen一起投入。回想在準備上課資料的過程中，因為對於攝影只有粗淺瞭解，只能很土法煉鋼地去圖書館找攝影集當教材，三個人摸索一陣子後，直到小江加入才有上軌道的感覺。工作坊前，苦力們經常徹夜不眠地討論、規畫課程，過程中大家最常說的一句話是：「我們這樣會不會太幸福啊？！」因為每次討論前都買附近小吃店的各式熱炒，夏天外加超好吃綠豆粉條，看到滿桌吃食，但正事卻還沒討論出來，不禁罪惡感油生才會有如上感嘆。但最終在外勞學員、及TIWA工作人員的共同努力下，攝影展還是要進行了，大家共同完成一件事的感覺還真棒。

好了，夜深了，也許該登入MSN，進行再一次的攝影工作坊MSN會議。

移工攝影班苦力

33

The Thing We Did Together

Tracy Shu

In this workshop, I decided to take on administrative matters so as to marginalize myself (which echoes my own problematic patterns). Moreover, due to my poor English, I was not brave enough to talk to the migrant workers; as a consequence, I again missed opportunities to further approach them. Nevertheless, with the advance of the workshop, not only the members but also I myself learned so much——reflections and insights were repeatedly prompted, for example: "Wow, how can pictures be taken like this"; "So this is how they interpret their work"; "I never expected that they feel this way about things"; just to name a few.

Though I am a graduate in labor studies and a former civil servant in the municipal government's migrant workers "management" sector, I never expected to enter into the labor field again. However, I still took a post in a grass-root labor union after all. Sometimes I thought, during this migrant workers photo workshop, if members of our labor union came here to join, what kinds of images would they create? Maybe, I can be the first to try. What about a project of picturing my union work, for instance? That should be interesting!

To speak frankly, I do not think I contributed much to this workshop; my participation was originally for the purpose of supporting Jing-Ru's idea and therefore I called Ellen to join together. When later preparing instruction materials, I recall, owing to our limited knowledge of photography, we three coolies could only search the library in a rather amateur way, for photo albums to serve as texts. Not until Little Chiang's taking part did the somewhat directionless situation improve. Before

the workshop started, we usually discussed all night to design workshop activities. We often prepared an array of stir-fried dishes from near by eateries as well as, in summer, delicious sweet rice noodles but left the "business" unattended. Then we'd sigh, "Are we too decadent?" Nonetheless, after the collective efforts of all the workshop members and TIWA's staff, both the photo exhibition and the photo album were eventually just around the corner. It is so wonderful to do a thing together.

All right, now it is rather late in the evening. Maybe it is time for me to log on to MSN again to have another online meeting for this photo workshop.

Coolie of Photography Workshop

Translated by Tseng Han-Sheng

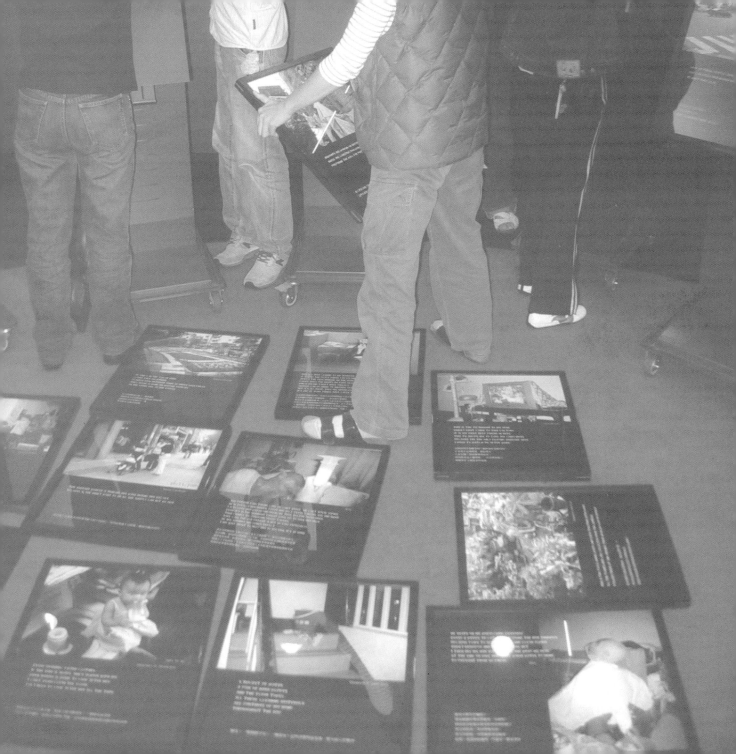

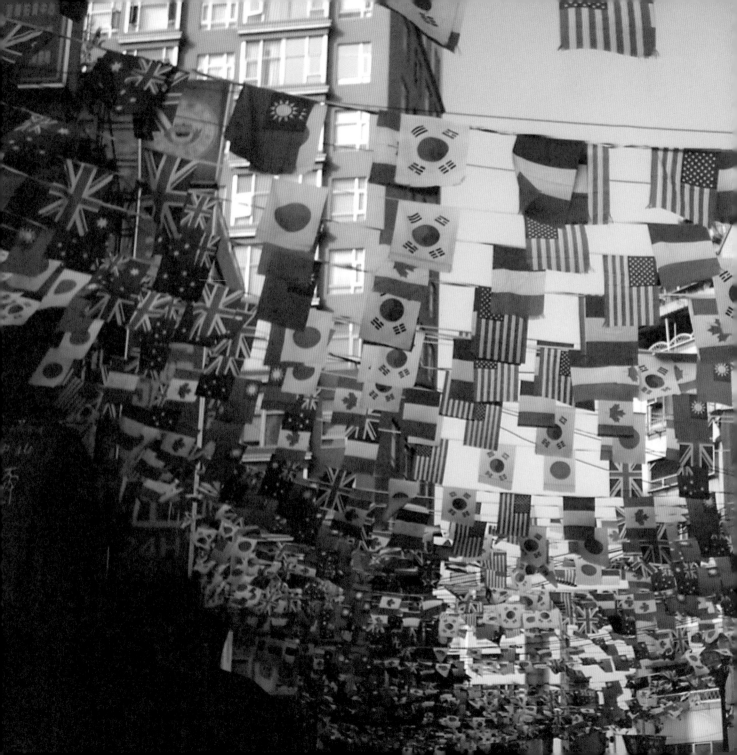

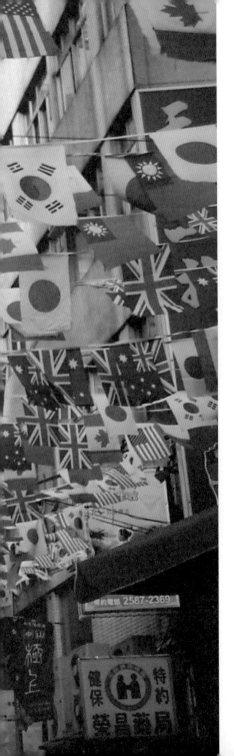

I remember one time, a fellow said to me that
if I could find a Philippine flag amongst these
various flags, he'd give me $100NT dollars.
Well, I know I'd never find one anyway.

Gracelyn G. Mosquera

記得有一次一個朋友跟我說，
如果我可以在這片旗海裡找到一面菲律賓國旗，他就給我100塊台幣。
噢，我當然知道我是不可能找得到的。

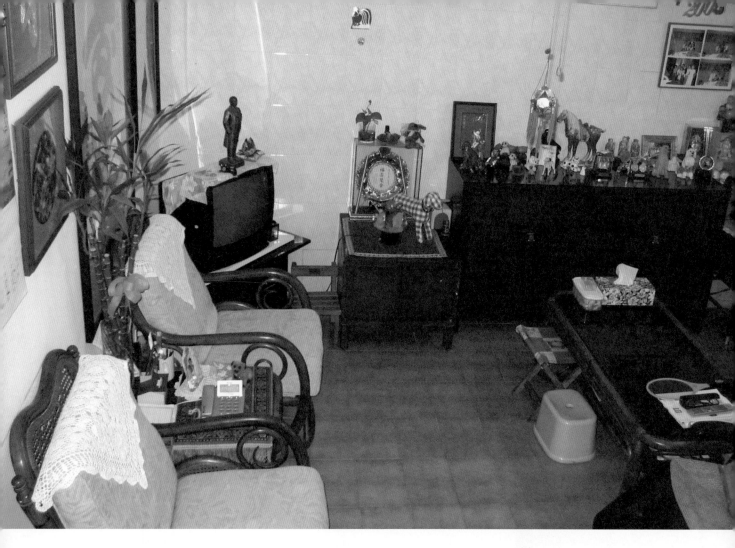

It is hard to believe what I have been doing for the past two years.
One of my boring jobs that I've always been doing every morning,
is to remove the dust of these different displays in this living room.

Elizabeth R. Dela Cruz

很難去想像我這兩年來所做的事情。
其中一件非常無聊的工作，
是每天早上把客廳裡的這些小擺飾一一擦拭乾淨。

This is the place where Waypo and I stay together after walk.
All the plants here are collected from the garbage.
I picked them up and arrange them in such a way by myself.

Elizabeth R. Dela Cruz

我陪外婆散步過後總會一起在這裡小憩一下。
所有的盆栽植物都是我從垃圾裡撿來的。
我把拾來的盆栽重新整理佈置好變成現在這個樣子。

Everyday between 4:00-5:30 pm...rain or shine, I come visit my garden planted with different kinds of green vegetables while Akong is doing his routine exercise on the other side of the garden.

Maricel Santiago

每天的四點到五點半,風雨無阻,
我都會來看看我種滿各式綠色蔬菜的花圃,
這時阿公會在花圃的另一邊,
做著他每天例行的運動。

This migrant worker is bringing her ward during her day off,
because if she didn't want to do so, she simply can not go out.

Blesilda Candingin

這位移工在休假外出時帶著雇主的小孩同行。
因為如果她不這麼做，她就沒辦法出門。

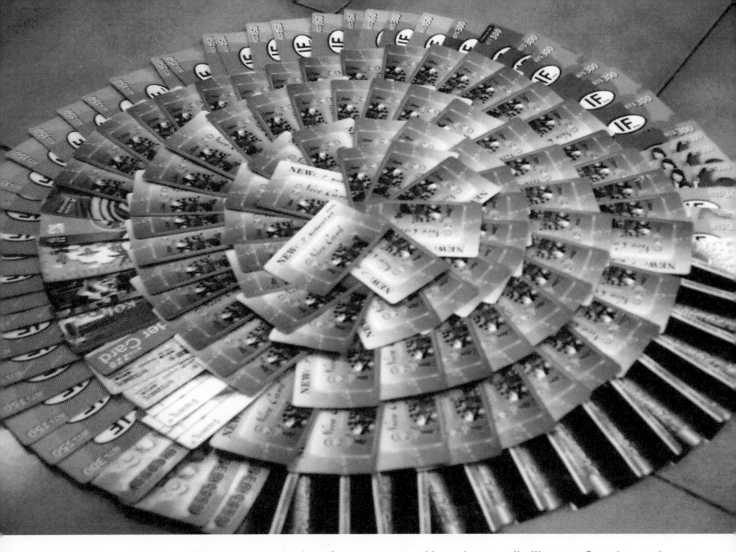

Migrants spend a lot of money on making phone calls like me. See these phone cards? I have collected them.
It simply tells how lonely migrants are.

Gracelyn G. Mosquera

移工們花大把的鈔票在打電話上，我也不例外。
看到我收集的這些電話卡嗎？這讓人不難理解移工們有多寂寞。

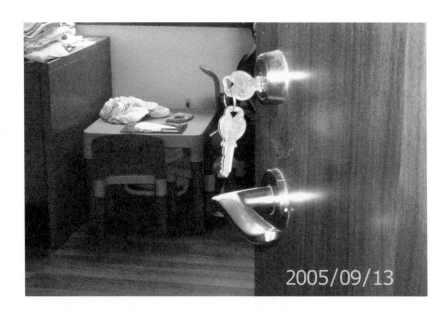

2005/09/13

This is a door leading to my bedroom;
it is also the place where I do folding and ironing of their clothes.
Notice the keys hanging on the door? They are always there.
I don't have the rights to take away the keys, which means,
I don't have privacy. Anybody can go inside at anytime even during my sleep.
But it's all right, they are harmless, I believe so.
It's one of many things that I need to deal with while I am working here.

Cyd Charisse B. Sannoy

這是通往我睡房的門；
我也在這房間裡幫雇主燙衣服摺衣服。
注意到插在門鎖上的鑰匙嗎？一直是掛在那裡的。
我沒有拿走鑰匙的權利，這也代表我其實是沒有隱私的。
任何人想進來我房間都可以隨時開門進來，甚至當我熟睡時。
不過沒關係，屋裡其他的人應該是不會對我怎樣的，至少我是這樣相信。
何況這只是許多我必須去適應的事裡頭的一項罷了。

Inside the left door is where our kitchen is located
while the right door is our bath room.
Our living room is located on the right side
where the surveillance camera is facing.

Ronel Gonzales

左邊那扇門的後面是廚房，
右邊的門通向浴室。
我們的客廳則是在右側，
監視器正對著的地方。

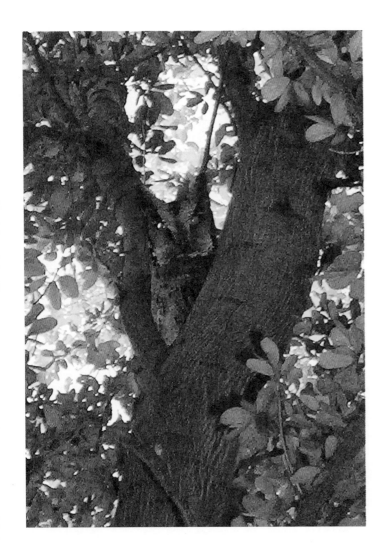

An owl stay in a tree outside
the window
of our factory
is watching us
while we take a break.

Ronel Gonzales

工廠的窗外，
有隻棲在樹上的貓頭鷹
正盯著休息中的我們瞧。

This is the kind of food
that serves in my factory,
and I dislike the taste.
Every time I open this box,
I already lose my appetite.
But still, I force myself
to eat because I need to.

這是工廠裡提供的食物，
是我不喜歡的口味。
每次一打開便當盒，
我就已經失去食慾了。
不過，我還是勉強自己去吃，
畢竟我還是需要吃東西。

Later I found out that if I
add some sauce from Philippines,
it tastes much better.
Now every time I eat, I just add
some sauce so I can eat.
I no longer need to worry about the taste
as long as I have the sauce with me.

Alice E. Dimzon

後來我發現，如果我在食物裡加些菲律賓醬料，
味道就變得好多了。現在每次我吃便當，
我都放些醬料，就吃得下了。
只要有我的醬料，我再也不擔心食物的口味了。

Behind the window grills is our neighbor. Everyday, I always see an old lady there cooking and doing laundry, etc. In fact, we do have the same cooking schedule in the afternoon.
I just can't stop wondering why she is doing all the home chores when I do see also younger people live in the same house. I feel pity for her because in the Philippines, it is common practice that grandmothers or old people usually stay at home and do less home chores.
Maybe her situation is different, I don't know.

Cyd Charisse B. Sannoy

鐵窗後面是我們的鄰居。每天我都會看到一位老太太在那邊做菜洗衣。
事實上，我們傍晚做菜的時間是一致的。
我忍不住感到疑惑，
明明看到屋裡有其他年輕人，為什麼這些日常雜務都是老太太包辦？
我真同情她，因為一般菲律賓的老人家是不需要做太多家務事的。
會不會是這位老太太的狀況較特殊？這我就不知道了。

An Ching's class has been part of kids' daily life
at very young age and so do I...
only that I stay outside the door and wait
while the kids get into the classroom.

Mechille Dacuno

安親班是小小孩每天生活的一部份，也是我的一部份。
只不過我留在門外等而小孩進教室去。

Upon seeing the "Chemotherapy room", I have a mixed emotion,
nervous and sad. The atmosphere looks like all the cancer patients were seated,
including my ward. Mostly had dextrose catheter by arms or chest.
If I had that fear, it must be the same with my ward; he is scared too.
Some patients were walking toward the toilet, more often
because they are having diarrhea, or to throw up, due to chemo effect.

Ma. Belen Batabat

看到化療室讓我產生複雜的情緒，混合著焦慮與悲哀。
整個氣氛如同所有的癌症患者排排坐著，多半都掛著點滴在手臂或胸口，包括我照護的人。
如果我會感到恐懼，我照護的人一定也是，他會害怕。一些病人往來洗手間，因為化療容易引起腹瀉或嘔吐。

This is the stairs that I vacuum
every day, from 1st floor
up to the 4th,
because of the fallen hair
of that cute dog that I care.

Evangeline L. Agustin

我每天都用吸塵器清理這樓梯，
從一樓清到四樓，
因為到處都有這隻
我在照顧的可愛狗狗的毛。

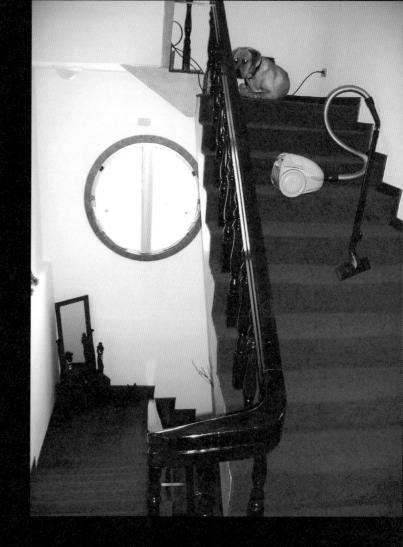

This house has 8 toilets including my toilet. I'm a little bit lucky
because I clean every day only 4 toilets. The others, once or twice a week.

Evangeline L. Agustin

這個房子總共有八個廁所，包括我的在內。
我還蠻幸運的因為我每天只要清理四個馬桶。
至於其他的，一星期清理個一兩次就行了。

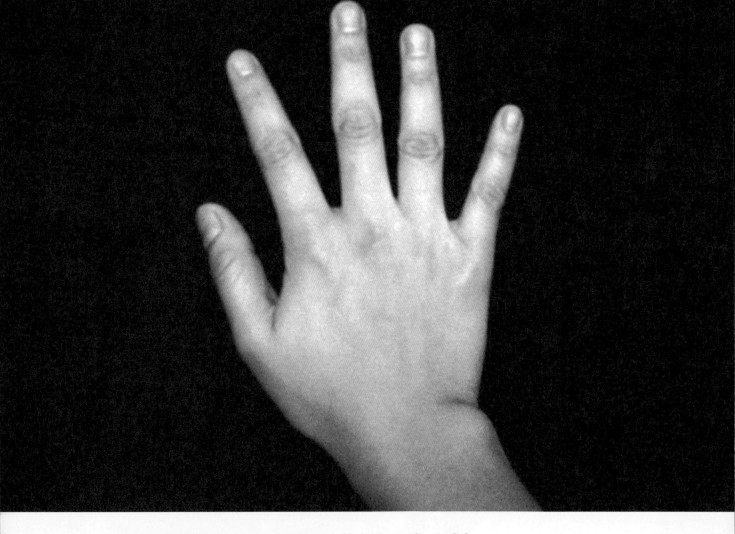

Take a look at my hand. Don't you think it's perfectly fit?
By looking at the appearance, it seems alright, yet you may not realize that
beyond its appearance, it feels hurt, sometimes numb, moments that
I could hardly close my hand or bend my fingers.

Mechille Dacur

看看我的手，很勻稱不是嗎？
外表看似不錯，但你一定不曉得在表象之下，
這手會痛、會麻，有時會疼到難以握拳或彎曲手指。

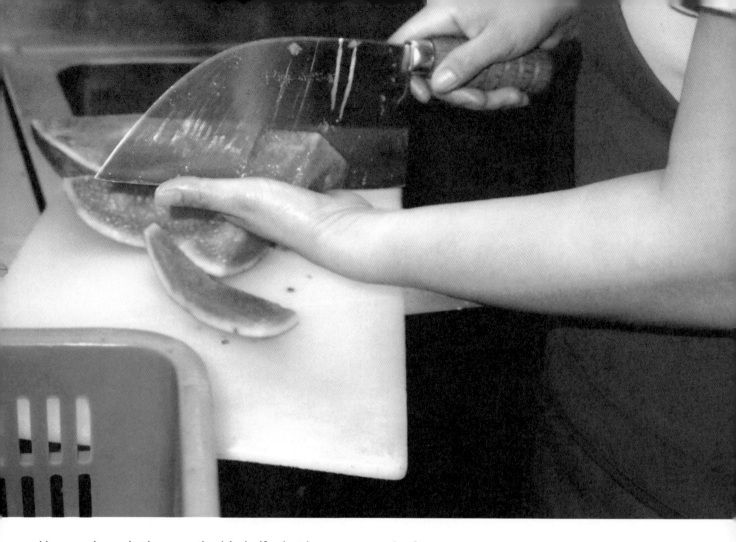

Her employer let her use the big knife that is suppose to be for meat.
It is very dangerous for cutting the fruit.
She has no choice only to follow her employer.

Glorette Platon

她的雇主給她使用這把切肉的大刀。
用這刀來切水果其實是很危險的。
不過她沒有什麼選擇，只能將就用。

Migrants take a 15 minutes break.
We have our busy day.
"Garbage time" is the most convenient
to see our fellow migrants.

Ma. Belen Batabat

移工們休息15分鐘。
我們忙了一整天。
倒垃圾時間是我們最容易遇到其他移工的時候。

Garbage Rule, a very good discipline
and can help to avoid air pollution and good for the environment.
But it's so unfair to a worker like me
that every time somebody put garbage in a wrong container,
they blame us.

Ellen R. Panaligan

垃圾分類是非常好的習慣，可以避免空氣污染並保護環境。
很不公平的是，每當有人放錯分類，大家都怪到我們頭上。

I called my bed as a seat for a day and a bed for a night.
This is where I sleep, a "sofa bed". Although it's like this,
I'm so thankful because good treatment really counts more for me
than a small place to rest. Besides, their home is quite small.

Ma. Belen Batabat

我稱我的床為白天的座椅晚上的床。這是我睡覺的地方，是張沙發床。
雖然如此，我還是心懷感激，因為對我而言，好的對待比什麼都重要。
何況，這房子本來就不大。

This is my bed. I hate it,
because I always need to fix it,
even in the middle of the night.

Glorette Platon

這是我的床。我很受不了它。
因為我老是必須爬起來把它拼回去，甚至在夜裡。

When they break something, usually I am not too strict with them
but to remind them to be careful and let things go.
After all, they are still kids.
But if they keep damaging things, I'd make them fix things by themselves
so to let them learn to be responsible for what they do.

Cyd Charisse B. Sannoy

當孩子們弄壞東西，我多半不太會嚴格去管，只會提醒他們要小心點。畢竟還是小孩呀。
但是如果他們繼續搞破壞，我可就會要求他們自己想辦法修，藉此讓孩子們學習為自己的行為負責。

This is the only person who makes me laugh everyday.
If she wasn't born, my days would be very boring

He seats on his wheelchair everyday.
Every 2 weeks, I'd cut his hair using the hair trimmer,
because I like to see him neat and clean always.
Then I shampoo him using the hair net.
I then dry his hair with towels and wrap his head.
At the end, I'd give him some warm water to drink,
to prevent from sickness.

他每天都坐在輪椅上。
我每兩個星期會幫他理一次頭髮，
因為我喜歡他看起來乾淨清爽的樣子。
剪完頭髮後，我會幫他洗頭，
用毛巾擦乾，再把頭包起來。
最後，我還會給他喝一些溫水，避免他著涼。

我的工作裡最讓我難以忍受卻又不能不做的部份是，
每隔一天，我都得要用手指幫他把便便解出來。
雖然已經使用了灌腸劑，但那實在沒多大用處，
因為他完全沒有能力自己排泄。

This is part of my job that I hate,
but I have to do this every other day,
by using my fingers to remove his poop out.
Even I use enema, it's still not much of the help,
because he really has no strength to push it out.

Emy I. Derder

How time flies so fast?
Every time I look at this clock tower,
I always remember the time
when I was in Hong Kong for 12 years.
You can find this clock tower in Tsim Sha Tsui.
Now I am here in Taiwan,
and still keep on beating the time,
and waiting for the time
I finally go back home for "good."

Lucile F. Alfaro

時間過得真快。
每次我看到這個鐘樓，
總會想起我待在香港的十二年。
尖沙咀就有一個像這樣的鐘樓。
現在我來到了台灣，時間仍是一分一秒的走著，
我等待著，如同以往般的在和時間賽跑，
等待著最終可以回到家的那一天的到來。

I was happy when I took this picture,
not because of this tallest building
in the world, but because my employers
were so supportive that they helped me
to get to this place just to take a picture.

Gracelyn G. Mosquera

能夠拍到這張照片讓我很高興。
並不是因為我拍到了世界上最高的建築物，
而是因為我的雇主們對我的支持。
他們帶我來到這個地方只為了給我找到好角度拍這張照片。

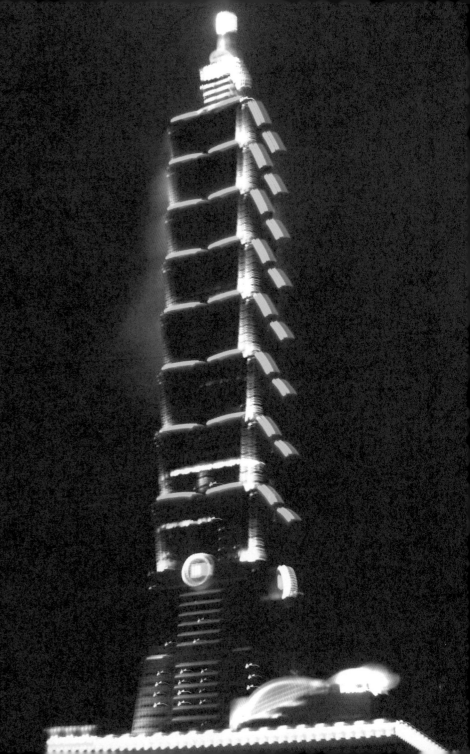

The public library. I read news here almost every morning on weekdays.
It's very convenient, especially when I go to use computers,
it's for free! And the staffs are very friendly and accommodating.
It's worth the taxes we paid.

Cyd Charisse B. Sannoy

這是公共圖書館。我幾乎每天早上都來讀新聞，
很方便。尤其是電腦，是可以免費使用的！
而且圖書館員非常親切友善，
這些都讓我覺得我們繳出去的稅很值得。

Variety of Philippine newspapers and magazines can be found here.
Even they are too pricey, my month can not be completed without
buying some of them, because they are written in the language
that I can read. I have no time to learn how to read Chinese.

Ma. Christina Antipala

各式各樣的菲律賓報紙雜誌都可以在這裡找到。
價錢並不便宜，但是如果我沒有買它個幾本，
是無法好好度過一整個月的。
因為這些是我熟悉理解的語言文字，
我忙到沒時間學習閱讀中文。

A migrant is so happy to find the string beans.
She thought she could only find this kind of
vegetable in her country.
Now she doesn't really miss the food from her country.

Glorette Platon

一位買到長豆而顯得很高興的移工。
她本以為只有在故鄉才找得到這種蔬菜。
現在她可以不必再害食物思鄉病。

It was in April 2005, while standing on this crossroad
waiting for the red light signal, a car ran over my toes.
I was too shocked to even look at the license plate.
Fortunately, no pain or injury. I was thankful to God
for He has walking along with me even though
I am no longer devoted to Him since I left Philippines.

Maria Mechille Dacuno

2005年4月，當我站在這個街口等紅燈時，一輛車輾過我的腳趾。
過度驚嚇之餘我沒能記下車牌。好險我沒受傷或疼痛。
感謝神一路與我同行，即使我離開菲律賓之後就不再那麼虔誠。

This picture describes me as an artist.
Painting and drawing are my hobby
that I can make money of
and once have saved me from hunger
when I got no more money
while processing my application of coming
here in Taiwan.
Wherever I go,
my tools are always with me.

Gracelyn G. Mosquera

這張照片是我身為藝術家的寫照。
繪畫與素描是我的嗜好也是謀生技能。
當我所有的積蓄都花在申請到台灣工作的那段時間，
就是靠著這技能才免於挨餓。
無論我到何地，這些畫具總是不離身。

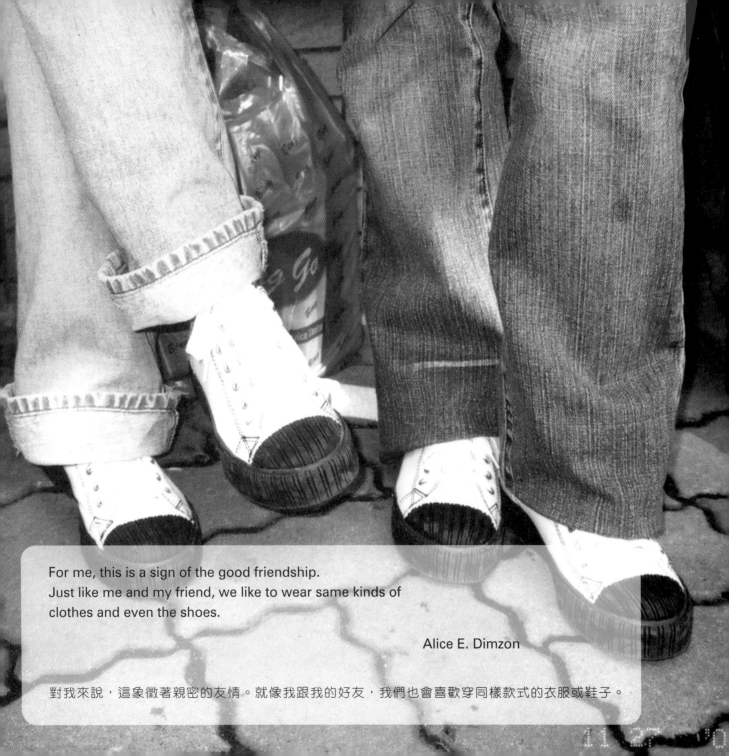

For me, this is a sign of the good friendship.
Just like me and my friend, we like to wear same kinds of
clothes and even the shoes.

Alice E. Dimzon

對我來說，這象徵著親密的友情。就像我跟我的好友，我們也會喜歡穿同樣款式的衣服或鞋子。

This lady is a Philippine migrant
who is earning some extra income
by providing service of manicure/pedicure
on the sidewalk of Chung Shan N. rd.

Blesilda Candingin

這位女士是菲律賓移工，
她在中山北路的人行道上
提供修剪指甲與足部美容的服務以賺取外快。

A Filipino is getting her eye brow tattooed,
it costs only a hundred NT dollar.
But I'd never want to do that.

Elizabeth R. Dela Cruz

一位菲律賓人正在紋眉，
只要台幣１００元就可以搞定。
不過我可不想嘗試。

A Filipino in the Salon is shampooing her hair
to make herself beautiful,
even it's on Sunday only.

Glorette Platon

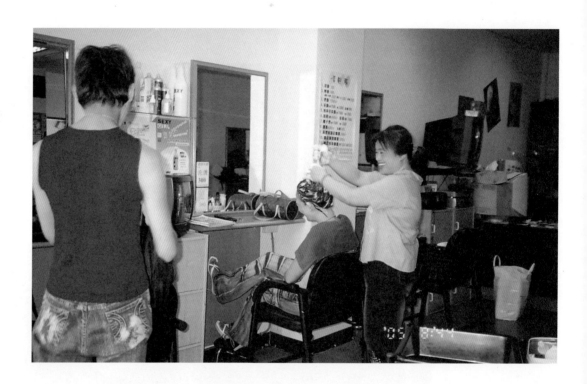

一位菲律賓移工正在美容院洗頭做頭髮，
好讓自己美美的，儘管只有在星期天。

Slippers need to be high
in order for me to feel high!

Ellen R. Panaligan

拖鞋要穿高一點的
好讓我自己覺得高。

This is how we sit on the table,
four of us, from left to right:
Madam, me, Akong and Ama.
Employee should be different from employer.

Maria Josefina M. Vaflor

這是我們餐桌上的位置。
從左到右：夫人，我，阿公，阿嬤。
受僱者與雇主是該有區別的。

This simple style but expensive table
troubles me. One time, one thing fell
and damaged the surface. Madam asked me
if I know the price. She said it is
two years plus two months of your salary.
Her words lingered, more than one month
for me to think about.

這張造型簡單但昂貴的桌子讓我憂心。
有一回，有個東西掉下來傷到桌面，
夫人就問我知不知道這張桌子多少錢。
她說：那是妳兩年加兩個月的薪水。
這句話在我耳邊響著，足足讓我想了一整個月。

Finger prints are used as evidence in some cases.
I didn't believe that. Now here on this table,
proved me that there's really a finger print.
So, when it comes to valuable things,
I've learned to be aware of toweling.

Maria Josefina M. Vaflor

指紋被用來作為某些事件的證據。
從前我並不相信這回事。
現在這張桌子證明了指紋的存在。
因此，在面對昂貴的物件時，
我學會時時擦拭。

I often use this sink. Nothing used to be displayed.
One time I temporarily put my clothes with hanger,
my boss saw it. The next day,
the rubber ducks were already
there.

我常用這個洗臉檯，檯面上原本什麼都沒擺放。
有一次我把晾在衣架上的衣服暫時掛在這兒，
我僱主看到了，隔天就出現了這些塑膠鴨子。

Every time I finish working
in the kitchen at night,
I may stay here inside
the toilet, to take a rest.
I sit on that slippers,
sometimes write letters,
read newspapers and listen to
Hello Taipei using the headphones,
and even call someone else.
I just do those things here.

Maria Josefina M. Vaflor

每次我結束晚間廚房的工作，我會待在這浴室休息一會兒。坐在這拖鞋上，或是寫信或是一邊讀報紙
一邊戴耳機聽「Hello台北」電台。有時候我也會打幾通電話。我都是在這裡做這些事。

This picture was taken on Sunday, that's why these brooms are at rest.

Gracelyn G. Mosquera

這張照片是星期天拍的，這也就是為什麼這些掃把都在休息狀態中。

Taiwanese has a Taiwanese ID and credit cards;
migrant has ARC (Alien Residential Certificate) and ATM card.
The only difference —— ours has limited usage.

Ma. Belen Bataba

台灣人有台灣人的身份證和信用卡；
移工有居留證及提款卡。
唯一的不同在於——我們的卡用途有限。

A migrant behind the gate is asking her friends outside
to transfer her money, because she has no day-off.
Here, freedom is the difference.

Ma. Christina Antipala

鐵門裡的移工正在請門外的朋友們幫她轉帳，因為她不能休假外出。
在這個地方，自由的定義大不同。

My friend told me, her employer is very generous in so many things like clothes, money, etc., but she is not generous in time —— time to rest, time to off, very strict.
Don't be late at work.

Ellen R. Panaligan

我朋友跟我說，她的雇主在許多事情
上都很大方，比方衣服啦，金錢等等
的。但是對時間卻一點也不慷慨——
休息的時間或是放假，非常嚴格。
工作千萬別遲到。

This is my table; a place where I eat
my breakfast, lunch and dinner.
I cannot join them inside the dining room.

Blesilda Candingin

這是我的餐桌；我在這邊吃早餐中餐晚餐。
我不能在他們吃飯的地方跟他們一起用餐。

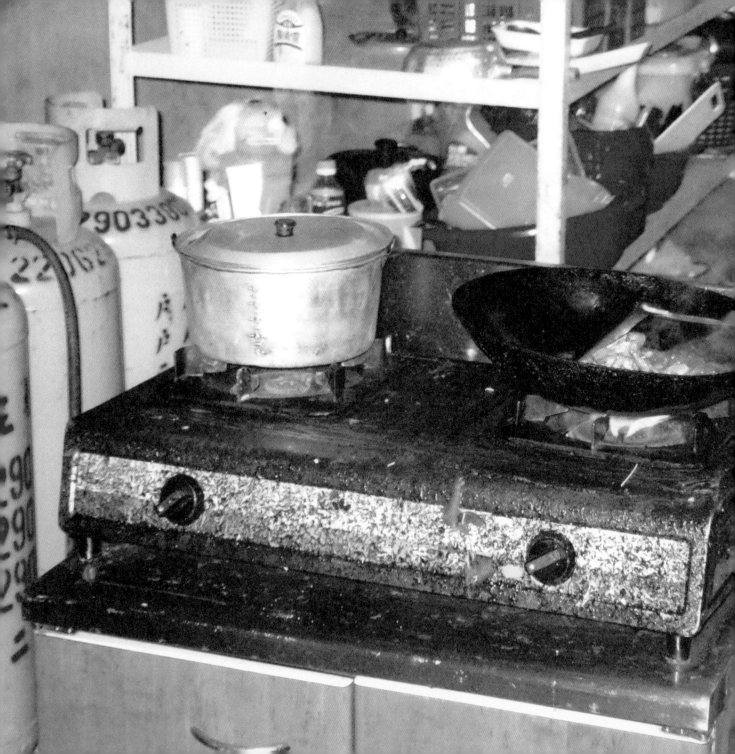

While cooking on this old gas stove,
I am afraid that it may explode in any second.
But still, I am happy because the employer allows
us to cook.

Alice E. Dimzon

當我在這個老舊的瓦斯爐上煮東西的時候，
我總是提心吊膽的，怕它隨時會爆炸。
不過我還是感謝我老闆，因為他允許我們在這邊煮東
西吃。

The above cups are my employer's side.
I have mine too which he bought before I came here.
At least I know where my boundaries are.

Ma. Belen Batabat

上層的杯子是我雇主的。我也有我的，是雇主在我來之前買的。
至少我知道我的界線在哪裡。

Whenever everybody is home, I prefer to use this table to dine
instead of the main dining table. I feel more comfortable eating here.
When I have the chance, I always like to keep a little distance from them,
to remind myself of my position and maintain a low profile at all time
as much as possible.

Cyd Charisse B. Sannoy

當每個人都在家時，我寧可在這張桌子用餐而不是在大餐桌，會覺得自在些。
通常我會盡量與雇主們保持一點距離，以提醒自己的地位，同時儘可能的時時保持低調。

Whenever I got sick, my employer told me that I got it from my friend outside, and they always required me to wear a mask, whenever they got sick they said it was because of the weather and they are not wearing a mask.

Ellen R. Panaligan

當我生病時，雇主會說我是
從外面的朋友那邊傳染的，
並要求我戴上口罩。
當他們自己感冒時，他們會
說是因為氣候變化的關係，
且從不戴口罩。

Here in Taiwan, people have freedom to choose their outfit,
though people may stare at you. As migrants, we don't have freedom
in clothing especially those who work in the house.
For if we wear sexy clothes, it is one of the reasons
for sexual harassment and rape cases.

Gracelyn G. Mosquera

在台灣，人們有選擇穿著的自由，儘管可能被盯著瞧。
我們移工可就沒有這方面的自由，尤其是家務勞工。
如果穿性感一點，很容易會成為遭到性騷擾甚至性侵的藉口。

If I had a choice, what would I rather be?
A migrant worker or a local Bin-Lang girl?

Elizabeth R. Dela Cruz

假如我可以選擇，那我會比較想做什麼呢？
移駐勞工？還是檳榔西施？

Maybe the artist is running out of canvas to paint this "Amah", I don't know. People are distracted while passing down the street, because it looks like a ghost on the wall.

Ma. Belen Batabat

或許這位藝術家要畫阿嬤時正好把畫布用完了？我不知。
不過路過這邊的人都會分神，彷彿見到牆上有個鬼。

Mostly, the buildings and houses here in Taiwan are very nice. But this building is very different. The wall outside is very clean, but inside is very dirty, almost looks like a haunted house.

Edcel Benosa

台灣的建築物看起來都很不錯。不過這棟不太一樣。外牆非常乾淨但是裡頭頗髒，看起來幾乎像個鬼屋似的。

Every morning, everybody wants to read newspapers.
The issues inside the newspaper, however, are not always good.
There are rallies, fighting, etc.
So all people tend to think negative not positive to our country.

Edcel Benosa

每天早上大家都看報。
報紙發佈的內容卻總是不太好。
遊行抗爭啦、戰爭啦等等的，
導致所有的人對這國家的看法
都往負面去而非正面。

Don't be mistaken if it is Christmas or Valentines Day. Those people wearing red are Taiwanese who were gathered to outburst their anger. How long the "Depose" gathering is going to be? Yet President Chen is still there.

Ma. Belen Batabat

Oh! It's great. You can see vegetables planted in pots.
People here are showing that even they don't have garden or farm;
still they have their way to plant.

Nida Quintay

哇，多棒啊！看到花盆裡種著蔬菜。
縱使沒有花園或農地，
這戶人家照樣可以有辦法種菜。

We call this tree as "Balite".
There is a superstitious belief in the Philippines that you can see ghosts near this tree and that's why we only see them in the forest, not on the roadside like here.

Nida Quintay

我們稱這種樹叫Balite。
菲律賓有種迷信的說法，
說這樹會招鬼。
這是為什麼我們只在森林裡
才看得到這種樹，
不會在大馬路邊。

This is county side.
If you don't know how to read their language nor speak, you surely get lost.
Unlike Taipei, where they have English translation of the street sign.

Glorette Platon

在市區以外，
如果你不會他們的語言文字，肯定會迷路。
不像在台北市，有英文翻譯的街名。

An old man in Ximenting is carefully checking his shoe lace products.
It's nice to see this old man wearing a business suit.
Even if he is only selling cheap product. One of a kind old man.
A very good character that anybody should notice.

Ma. Belen Batabat

在西門町的一位老者正仔細的檢查他賣的鞋帶。
雖然只是在賣便宜的東西，但他穿著西裝的樣子讓人感覺挺不錯。
好個特別的老先生，每個人都該注意到他美好的特質。

I observed that when it comes to reckoning,
Taiwan is 11 years behind compare to the date of Philippines.
Ex: 08 September 2006 (Philippines) 08 September 1995 (Taiwan)

Ellen R. Panaligan

結帳時，我察覺台灣的日期比菲律賓慢了十一年。
比方，2006年9月28日是台灣的1995年9月28日。

Mail box is a nice implement in Taiwan.
You don't have to go to the post office to mail,
especially for those who are very busy.
Philippines don't have this kind of system.
We must go directly to the post office.

Edcel Benosa

信箱是很棒的設置。
你可以不必到郵局去投遞,對忙碌的人尤其方便。
在菲律賓,我們只能直接去郵局寄信。

They use these bricks for building houses.
In the Philippines, we use gravel and sand.

Nida Quintay

他們用這些磚頭來蓋房子。
在菲律賓我們用的是碎石和沙。

It frightens me whenever I see people having tattoos.
Back home, people having a lot of back markings
were those convicted in jail.

Mechille Dacuno

看到身上刺青的人讓我心生恐懼。
在家鄉，背上有這類記號的人通常是進出過監獄的罪犯。

This is how they prepare food for all the occasions and it's really different from the Philippines.

Nida Quintay

這是他們為大活動準備食物的方式，跟菲律賓非常不一樣。

It is customary in the Philippines to use hands in eating and sometimes fork and spoon, while here in Taiwan, they use chopsticks.
I discover that it is easy and fast to eat noodles using chopsticks.

Ellen R. Panaligan

菲律賓的習慣是用手或刀叉吃東西。
台灣人習慣使用筷子。
我發現用筷子吃麵的確是又簡單又快。

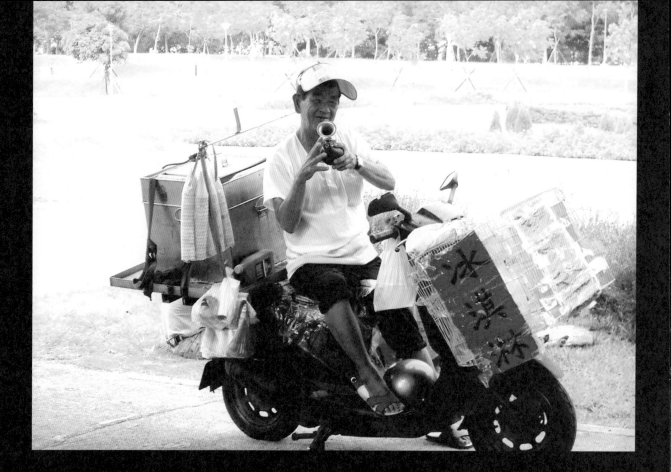

In Taiwan, this ice cream vendor is high-tech,
because he uses motorbike to sell it.
In the Philippines, they are using a pushcart
to sell ice cream.

Evangeline L. Agustin

這位台灣的冰淇淋小販真是高科技，
他用摩托車來賣冰。菲律賓的小販用的是手推車。

An innocent kid, playing on the road. Nobody takes care of him,
because his mother is busy selling breakfast.
Same as migrants' kids. Nobody looks after them and
so easily they become delinquent or stubborn.

Glorette Platon

一個在路邊玩耍的天真小孩，沒人看顧，因為他媽媽忙著賣早餐。
如同移工的小孩，父母不在身邊，容易成為倔強的問題小孩。

Different numbers indicate different bus routes for the commuters.
In my country, we use placards (name of the places) instead of numbers.

Blesilda Candingin

不同的號碼代表不同的公車路線。
我家鄉的公車並不掛號碼，我們依據的是指示地點的牌子。

In Taiwan there are different taxi companies but there is only one color,
that is yellow. So people can easily recognize them in the distance.
In Philippines, you can choose whatever color you wish.

Evangeline L. Agustin

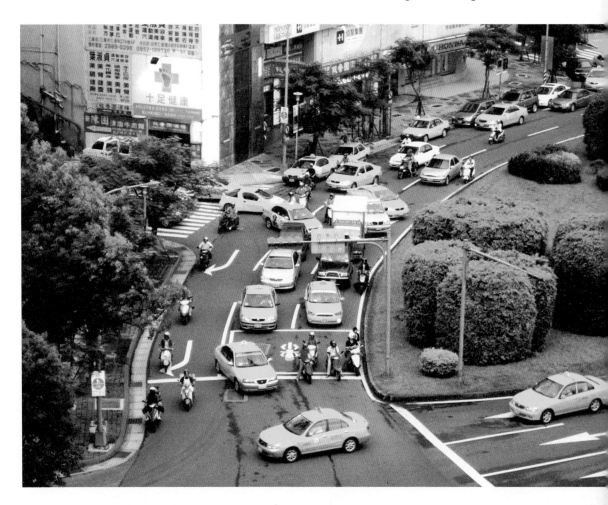

台灣有好多計程車行，但是車子只有一種顏色，黃色。
因此就算在遠距離也很容易辨識。
在菲律賓，你可以選擇任何你中意的顏色。

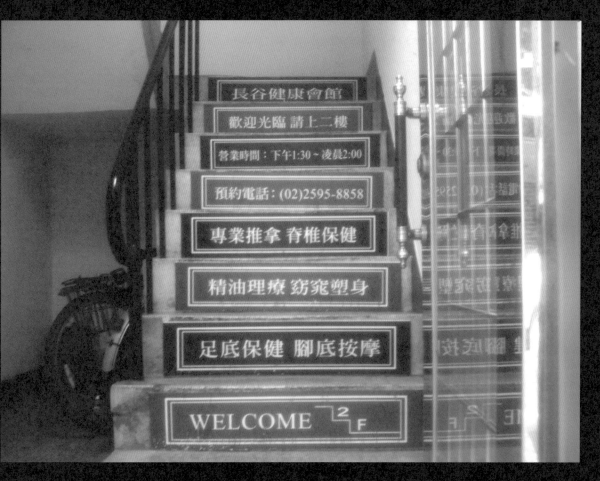

長谷健康會館
歡迎光臨 請上二樓
營業時間：下午1:30～凌晨2:00
預約電話：(02)2595-8858
專業推拿 脊椎保健
精油理療 窈窕塑身
足底保健 腳底按摩
WELCOME 2F

I am impressed by this stairs;
the design is very unique as advertisement.
I don't see this style of design in any part of Manila.

Jun M. Sanchez

這個以樓梯來做廣告的特殊設計讓我印象深刻。
我不曾在馬尼拉的任何地方見過這樣的設計。

慶讚中元普渡大法会

雨順

比安

天祝地孫應紀坤

北方真□濟嘗□

This is one of the Taiwanese traditions
which I haven't got an explanation about.
And that's definitely different from ours.

Ma. Christina Antipala

這是台灣的傳統民俗活動之一，
不過到現在我還搞不懂它的意思。
這樣的傳統是台灣跟我的家鄉非常不一樣的地方。

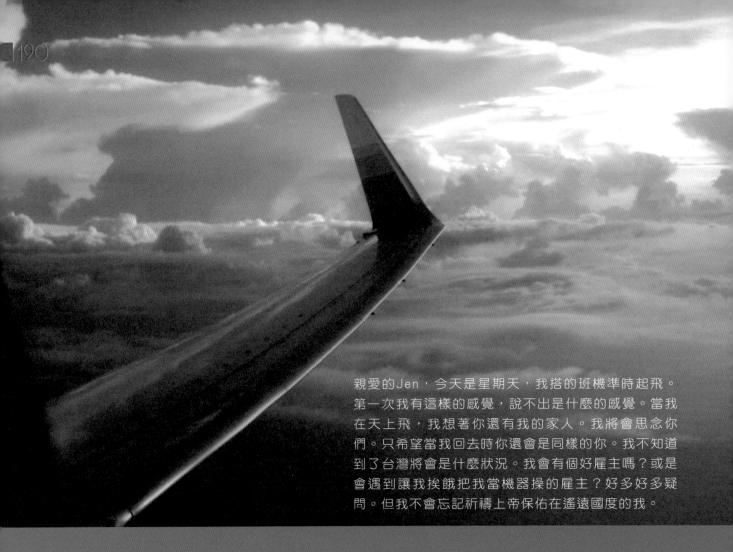

親愛的Jen，今天是星期天，我搭的班機準時起飛。
第一次我有這樣的感覺，說不出是什麼的感覺。當我
在天上飛，我想著你還有我的家人。我將會思念你
們。只希望當我回去時你還會是同樣的你。我不知道
到了台灣將會是什麼狀況。我會有個好雇主嗎？或是
會遇到讓我挨餓把我當機器操的雇主？好多好多疑
問。但我不會忘記祈禱上帝保佑在遙遠國度的我。

Dear Jen, it is Sunday. My flight lifts its wheels from the ground on schedule.
I'm having this feeling for the first time in my life, an unexplainable feeling.
When I was in the air, I was thinking of you and my family.
I will miss all of you, and I am hoping that you will remain the same
when I get back. I don't know what's awaiting me in Taiwan.
Will I get a good employer? Or will I get an employer that will starve me
and treat me like a machine? So many questions!
Yet I won't forget to pray that GOD WILL BLESS me in this foreign land.

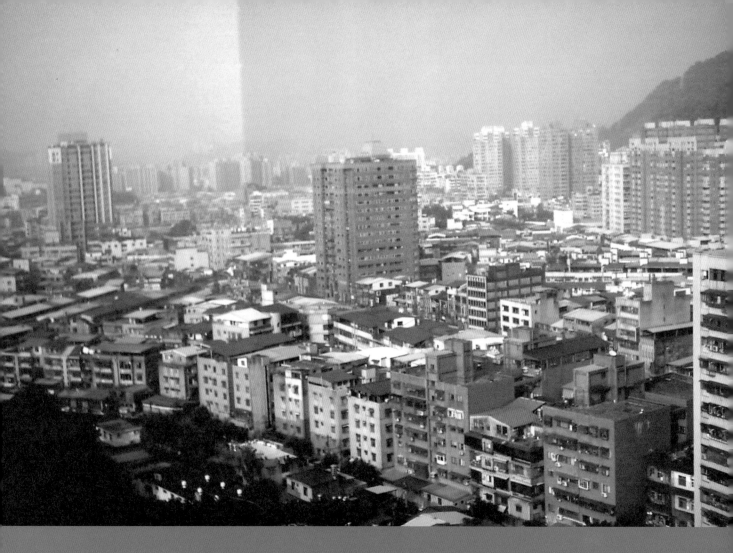

As I arrived, I saw tall buildings everywhere, and long expressways
which are very different from our country.
If Philippines has good economic situation,
I won't be leaving our country to risk myself.

Gracelyn G. Mosquera

在抵達時，我看到林立的高樓與綿延的高速公路，
跟我們國家大不相同。
要是菲律賓的經濟景氣，
我哪裡會離開家鄉面對這麼多不確定。

Dear Hazel and Herd, when I was a stranger
here in Taipei city, my employer asked me
to walk around and get to know this place.

親愛的Hazel和Herd，
當我對台北還很陌生時，
我的雇主要我到附近走走，
好好認識一下這地方。

One day my employer called me and
asked to go in a shop, a jewelry shop

有一天我雇主打電話給我
叫我到某家店去，
是一家珠寶店。

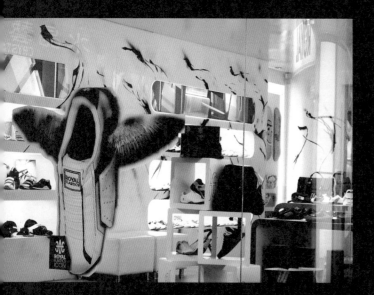

While I was walking, there was one shop that caught my attention, a shoe store named ROYAL ELASCTIC SHOES. The store has all the new styles I think, but I couldn't get inside to take a closer look because I don't have yet money to buy.

Since then, every time I walk this way,
I always make a wish, that someday or
before I go home, I will buy
these new shoes for both of you.
Till then, Take care always.

Evangeline L. Agustin

走著走著，一家店吸引了我的目光，那是一家鞋店，
叫ROYAL ELASCTIC SHOES 。
店裡都是些新款的鞋，
不過我沒能走進去看個仔細，
因為我還沒有足夠的錢去買。

從那天開始，每次經過這裡，
我都會在心裡許願：
有一天，在我回鄉前，
一定要為你們各買一雙。
在那一天到來前，請好好照顧自己。

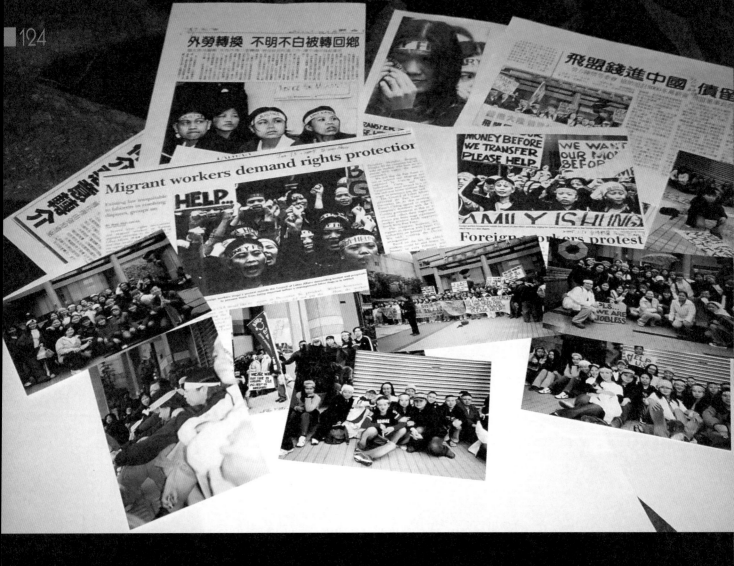

This is Fastfame case.
The company owes us 3 months of unpaid wages.
We fight until the company close and
this is the reason why I met TIWA.

這是「飛盟」事件。工廠積欠我們三個月的薪水，
導致我們起而抗爭直到工廠倒閉。
這事件亦是我與「國際勞工協會」結緣的開始。

This is the place where I worked
before. Every time I pass by,
I still feel the pain during
the Fastfame struggle.
It creates a traumatic experience
to every Fastfame workers.

這是我從前工作的地方。
每次經過這裡都會讓我回想到
當時抗爭過程的折磨。
這個事件在每個曾在「飛盟」工作的員工
心裡留下了陰影。

This is our dormitory when I was working
in Fastfame company. It's on the 4th floor.
We use stairs to get there. This is a very
old building, yet we were very happy living
here.

Alice E. Dimzon

這是「飛盟」的員工宿舍,在四樓。
我們都走樓梯上去。非常老舊的一棟樓,
可是我們曾在這裡度過很快樂的日子。

the others, once a two times
every day, lucky because
a week.
4 toilet

DIooooo!
DIooooo!

the this is the Sta
I use to baccum
every day, because if
fallen hair of that ant
dog that I care, from

many her ear see only ...
if you ear see ghost there
I know about that then
"Baku" there ...
We call this the

I hope mine - At least I
knew my han
the burning before which I
like - the hair
e:

frightened me whenever I see
people heavily w/ tattoos. Work
back home, people that has
a lot of Body marking were
those convicted in jail.

Till here; Take care
always.
Love, mummy
back & you.
I go home; I
wish that
again this new si

picture number. I
remember 4 see
during pain & injury happened. I was
thankful to God that He has
luckily along with me even though

It's amazing to
I don't know whats
the reason behind? People
are being disturbed
while passing down the
Street, cause it look like
ghost over the road.

Every morning, everybody
to read a newspaper, inside
newspaper's almost issues,
not good, there is a rally, p
ect. so all people thinki
negative not positive to ou
country.

CRITICISM
TAIWAN PEOPLE HAVE FREEDOM
THEIR OUTFIT. DIFFERENT STYLES.
LIKE THIS IN PHILIPPINES, PEOPLE
CITY. PEOPLE WOULD STARE AT
WE POSSIT HAVE FREEDOM IN
LY THOSE WHO WORKS IN
WE WEAR SEXY CLOTHES. IN THE
ALSO FOR SEXUAL HARASSMENT
SES.

112

112

employer let h

khife. But supposed

+.

across

so

In taiwan the vendor of
this ice cream is behio
because. he is using
motorbike to sell it
in the phil-they ar
a pushcart to
icecream.

Anching class has
of kids daily life
age & so adi...to
stay outside the
the kids get int

P. 38

Kuingat suatu ketika, temanku mengatakan akan memberikan aku 100 dollar jika dapat menemukan bendera Filipina di dalamnya. Wow, tentu saja aku tahu, aku tidak akan dapat menemukannya.

Tôi nhớ có 1 lần 1 người bạn nói với tôi, nếu tôi có thể tìm thấy trong 1 tấm biển cờ ,tìm thấy lá cờ philippin , anh ấy sẽ cho tôi 100 đồng. Ồ , đương nhiên tôi biết là không thể nào tìm thấy được.

P. 40

Aku sulit mempercayai apa yang telah aku lakukan selama 2 tahun terakhir. Salah satunya adalah mengerjakan pekerjaan yang membosankan, setiap pagi harus mengelap barang-barang kecil dari debu yang ada.

Rất khó tưởng tượng những công việc mà tôi làm 2 năm qua. Trong đó có 1 công việc vô cùng chán ngắt, là buổi sáng mỗi ngày tôi đem những thứ trang trí nhỏ nhỏ bày biện ở phòng khách lau chùi sạch sẽ.

P. 41

Ini adalah tempat istirahat bagi Waypo dan aku setelah lelah berjalan. Semua pot adalah hasil temuanku di tempat sampah. Semuanya aku susun ulang hingga seperti sekarang ini.

Sau khi Tôi đưa Bà ngoại tản bộ xong , thường thì dừng ở nơi đây nghỉ 1 tí. Tất cả các chậu trồng cây đều là tôi nhặt từ đồ vứt rác .Tôi đem các chậu sửa sang sắp xếp chúng thành như hiện nay vậy.

P. 42

Setiap hari setiap jam 4 sore hingga jam 5:30 sore, tidak hujan tidak panas, aku harus menyirami tanaman yang ada di kebun. Sementara akong sedang berolahraga di taman sebelah.

Mỗi ngày 4 giờ đến 5:30phút, bất kể mưa gió. Tôi đều đến vườn hoa thăm cái ngăn tôi trồng đầy rau màu xanh. Lúc đó Ông cụ ở 1 bên khác của vườn hoa, đang làm những động tác vận động mỗi ngày.

P. 43

Seorang TKA membawa anak kecil majikan selama ia sedang liburan. Jika tidak, maka ia tidak akan dapat keluar dari rumah.

Người lao động di dân này trong lúc được nghỉ phép đi chơi bên ngoài phải mang theo đứa con của Chủ.
Bởi vì cô ấy không làm như vậy , cô ấy không có cách nào ra khỏi cửa.

P. 44

Pekerja asing banyak menghabiskan uang untuk menelepon seperti aku. Lihat kartu telepon ini, aku mengumpulkannya sebagai bukti betapa sepi hati seorang TKA.

Dân lao động chúng tôi dùng rất nhiều tiền cho việc gọi điện thoại, tôi cũng không ngoại lệ.Có nhìn thấy tôi tích lũy những thẻ điện thoại không? Điều này cho thấy dân lao động chúng tôi chịu bao nhiêu là cô đơn buồn tẻ .

P. 45

Lorong ini menuju ke kamarku; kamar yang juga digunakan untuk menyetrika baju majikan. Apakah anda memperhatikan kunci yang tergantung di atas pintu? Selalu berada di atasnya. Aku tidak memiliki hak untuk mengambilnya, ini juga berarti aku tidak punya privasi. Setiap orang dapat masuk ke kamarku kapan saja mereka mau, bahkan ketika aku terlelap dalam tidur. Namun tidak mengapa, orang dalam rumah tidak akan berbuat apa-apa terhadapku, setidaknya aku dapat mempercayainya. Lagipula, ini adalah salah satu penyesuaian diri dengan lingkungan.

Đây là cánh cửa thông đến phòng ngủ của tôi; và cũng ở căn phòng này tôi giúp chủ ủi và gấp quần áo.Có nhìn thấy chìa khóa cắm ở khóa cửa không? Chìa khóa này lúc nào cũng ở đấy. tôi không có quyền giữ chìa khóa, đây cũng là điều nói thật, tôi không có quyền riêng tư của tôi.Bất kỳ ai muốn vào phòng tôi đều có thể mở cửa vào được, thậm chí cả khi tôi ngủ say. Nhưng không sao, những người khác trong nhà này chắc là họ không làm gì tôi , ít nhất là tôi tin như vậy . Đây chỉ là điều mà tôi phải thích ứng trong nhiều tình huống mà tôi phải thích ứng.

P. 46

Pintu kiri adalah dapur kami, sementara pintu kanan adalah kamar mandi. Ruang keluarga berada di sebelah kanannya, dimana kamera pengintai tepat berada di se-berangnya

Bên trái kia sau cánh cửa là nhà bếp, bên phải cửa thông với phòng tắm.Phòng khách chúng tôi nằm bên phải , có đặt máy quan sát.

P. 47

Di luar jendela pabrik, ada seekor burung hantu yang mengamati kami tidur siang.

Ngoài cánh cửa sổ công xưởng, đúng lúc nghỉ trưa ,có một con cú mèo đang dương cặp mắt ngó chúng tôi.

P. 48

Ini adalah sajian makanan dari pabrikku, dan aku tidak suka dengan rasanya. Selera makankupun hilang setiap aku membuka kotak makanan. Namun aku tetap me-maksakan diri untuk memakannya, karena aku membutuhkannya.

Công xưởng này cung cấp thức ăn, là những thức ăn không hợp với khẩu vị của tôi . Mỗi khi mở nắp cơm hộp , tôi đã không còn muốn ăn. Nhưng tôi vẫn phải tự ép mình ăn , suy cho cùng thì tôi cũng cần phải ăn.

P. 48

Akhirnya aku menemukan rasa yang lebih nikmat dengan saus dari Filipina. Kini aku selalu menambahkan sedikit saus di atasnya. Akupun tidak perlu lagi khawatir dengan rasanya selama aku memiliki saus ini bersamaku.

Sau đó tôi phát hiện ,nếu trong thức ăn tôi cho thêm 1 ít tương của Philippin , mùi vị sẽ khác đi rất nhiều. Bây giờ mỗi lần tôi ăn cơm hộp , Tôi đều bỏ 1 ít gia vị tương vào thì có thể ăn được rồi. Chỉ cần có gia vị tương của tôi, tôi sẽ không còn phải lo khẩu vị thức ăn nữa.

Di belakang terali besi adalah tetangga kami. Setiap hari kami temukan seorang nenek tua yang sedang memasak dan mencuci baju. Semuanya hampir dilakukan dalam waktu yang bersamaan dengan kami. Aku merasa kasihan, karena biasanya di Filipina nenek yang tua tidak perlu lagi bekerja terlalu banyak. Mungkin saja situasi di Taiwan berlainan, namun aku tidak tahu apa alasannya.

Phía sau cánh cửa sổ sắt nhà chúng tôi là nhà hàng xóm .Thường ngày chúng tôi nhìn thấy một bà già bên đó nấu ăn ,giặt quần áo.Thực ra , buổi chiều tối Bà ấy và chúng tôi nấu ăn thời gian đều giống nhau .Tôi nhịn không được và cảm thấy nghi hoặc, rỏ ràng trong căn nhà ấy ngoài ra còn có 1 số người trẻ hơn , tại sao tất cả việc thường ngày lại để cho một Bà già phục vụ? Tôi thật thương Bà ấy, thường thì người già bên Philippin không cần làm nhiều việc gia đình. Có thể Bà là trường hợp đặt biệt chăng? điều này thì tôi không biết .

Kelas An Ching adalah bagian dari kehidupan anak-anak kecil, juga bagian dari kehidupanku. Hanya saja aku harus menunggu di luar sementara mereka masuk ke dalam kelas masing-masing.

Lớp học An Ching là 1 phần trong cuộc sống mỗi ngày của trẻ, cũng là 1 phần cuộc sống của tôi. Chỉ có khác là tôi ở bên ngoài cửa đợi, còn các bé thì vào trong phòng học.

Seusai mengamati ruang Kemoterapi, hati menjadi galau dan sedih. Atmosfir hati ibarat para pasien yang duduk berbaris di sana, sebagian masih dalam keadaan di-infus, termasuk yang aku jaga. Jika aku dapat merasakan ketakutan, maka niscaya mereka juga demikian. Sebagian pasien keluar masuk kamar toilet, karena pengobatan tersebut dapat membuat mereka menjadi sakit perut dan mual.

Nhìn thấy phòng hóa học trị liệu trong tôi sinh nhiều cảm giác,phức tạp lo lắng và đau xót. Bầu không khí giống tất cả các bệnh nhân ung thư ngồi xếp hàng ở đây, hơn phân nửa họ là vô nước biển ở tay hoặc ở ngực, kể cả người bệnh mà tôi đang chăm sóc. Nếu tôi cảm thấy hoảng sợ, thì người tôi chăm sóc nhất định cũng vậy . Một vài bệnh nhân đi về hướng phòng vệ sinh, bởi vì trị liệu hóa học dễ làm cho người bệnh tháo dạ hoặc ói mữa.

P. 52

Aku harus menyedot debu setiap hari, mulai dari lantai 1 hingga 4, karena banyaknya bulu anjing yang kujaga berterbangan.

Mỗi ngày tôi đều dùng máy hút bụi làm sạch cầu thang này, từ lầu 1 đến lầu 4. Bởi vì khắp nơi đều có lông con chó dễ thương mà tôi chăm sóc .

P. 53

Rumah ini ada 8 kamar mandi, termasuk milikku. Beruntungnya aku, karena setiap hari hanya perlu membersihkan 4 saja, sementara yang lain cukup sekali atau dua kali dalam seminggu.

Nhà này có tổng cộng 8 phòng vệ sinh, tính luôn phòng vệ sinh tôi đang dùng. Tôi vẫn còn may mắn bởi vì mỗi ngày tôi chỉ cần dọn vệ sinh 4 phòng, còn những phòng khác 1 tuần chỉ cần một , hai lần dọn vệ sinh thôi là được.

P. 54

Lihat tanganku, sepertinya tidak bermasalah bukan? Namun anda mungkin tidak tahu penderitaan yang ada di belakangnya, kadang sakit, keram, kesemutan, bahkan tidak dapat memegang barang ataupun menggerakkan jari.

Nhìn tay của tôi, không phải là rất cân đối sao?Nhìn vẻ bên ngoài thì cũng không tệ , nhưng nhất định bạn không nghĩ được với lớp bề ngoài của đôi tay này bên trong nó bị đau, bị tê , có lúc tay bị đau buốt rất khó khăn khi nắm tay hoặc co các khớp ngón tay lại.

P. 55

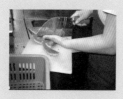

Majikan memberikan pisau besar untuk memotong daging. Namun sangat berbahaya jika digunakan untuk memotong buah-buahan. Ia tidak memiliki pilihan lain.

Chủ của Cô ấy đưa cho Cô ấy con dao xắt thịt, dùng con dao này xắt trái cây thực ra rất nguy hiểm, nhưng Cô ấy không có cách nào để lựa chọn, chỉ có thể dùng như vậy.

P. 56

TKA berisitirahat hanya 15 menit. Setelah lelah bekerja seharian, "Waktu buang sampah" adalah waktu yang paling tepat untuk bertemu dengan rekan sekampung.

Người lao động chúng tôi giờ nghỉ 15 phút. Chúng tôi bận cả ngày. Đến giờ đổ rác là giờ chúng tôi dễ gặp được các bạn lao động khác.

P. 57

Pemisahan sampah merupakan kebiasaan yang baik, selain dapat mengurangi polusi juga turut menjaga lingkungan hidup. Namun tidak adil bagi pekerja seperti aku yang selalu disalahkan jika ada orang lain yang membuang sampah ke tong yang salah.

Thói quen phân loại rác rất tốt, có thể tránh được ô nhiễm không khí và bảo vệ môi trường .Không công bằng là khi mỗi khi có ai đó phân loại rác sai, mọi người đều trách mắng chúng tôi.

P. 58

Kupanggil ranjangku sebagai sofa di siang hari dan ranjang di malam hari. Ini adalah tempat aku tidur, ranjang sofa. Bagiku yang terpenting adalah sikap baik dari majikan. Lagian, rumah di Taiwan memang sudah cukup sempit.

Tôi gọi cái giường của tôi là ghế ngồi buổi sáng, là cái giường ngủ buổi tối. Đây là chỗ ngủ của tôi, là tấm giường sofa. Tuy là như thế, tôi vẫn mang lòng cảm ơn, bởi vì với tôi mà nói, cách đối xử còn quan trọng hơn so với mọi thứ. Huống chi, cái phòng này vốn dĩ nó đã rất nhỏ.

P. 59

Ini adalah ranjangku, dan aku benci terhadapnya. Karena aku harus selalu memasangnya kembali sekalipun sudah terlelap di malam hari.

Đây là giường ngủ của tôi. Tôi chịu không nổi nó, bởi vì buổi tối phải thức dậy tôi thường phải gập nó lại.

133

P. 60

Ketika mereka memecahkan barang, aku biasanya tidak pernah bersikap terlampau keras, hanya meminta mereka untuk lebih berhati-hati. Namun jika mereka terus bersikap kekanak-kanakan dan merusak barang, maka aku akan meminta mereka untuk memperbaikinya. Ini adalah satu cara untuk belajar bertanggung jawab.

Khi những đứa trẻ làm hỏng đồ đạc, đa phần tôi ít khi nghiêm khắc , chỉ nhắc nhở chúng nên cẩn thận hơn 1 chút. Suy cho cùng chúng vẫn còn trẻ con. Nhưng nếu chúng tiếp tục làm hỏng đồ đạc, tôi sẽ yêu cầu chúng nghĩ cách sửa chữa,nhờ vậy làm cho những đứa trẻ học cách biết chịu trách nhiệm việc làm của chúng.

P. 61

Ini adalah satu-satunya orang yang dapat membuat aku bahagia. Jika tidak ada kehadirannya, maka hari-hariku akan terasa bosan dan juga ia adalah alasan bagiku untuk rindu akan rumah.

Đây là người duy nhất mỗi ngày cho tôi niềm vui. Nếu như không có cô ấy,những ngày tháng của tôi sẽ rất vô vị ,Tôi sẽ phải nhớ nhà biết bao.

P. 62

Ia duduk di atas kursi rodanya. Setiap 2 minggu kubantu memotong rambutnya, karena aku suka melihatnya dalam keadaan rapi. Setelah selesai, kubantu menyu-ci rambutnya, mengeringkannya dan membungkus kepalanya. Terakhir, aku akan memberinya minum air hangat, agar tidak masuk angin.

Ông ấy mỗi ngày ngồi trên ghế xe lăn. Hai tuần 1 lần tôi giúp ông ấy hớt tóc , bởi vì tôi thích nhìn thấy ông ấy sạch sẽ thoải mái như vậy. Sau khi cắt tóc xong, tôi giúp ông ấy gội đầu,dùng khăn lông lau khô, quấn đầu lại. Sau đó, tôi cho ông ấy uống 1 ít nước ấm, tránh cho ông ấy bị lạnh.

P. 63

Ini adalah bagian pekerjaan yang aku benci, yakni membersihkan kotorannya dengan jariku setiap hari. Walau telah kugunakan alat pembersih, namun tidak memuaskan, karena ia tidak dapat membuang kotoran sendiri dari tubuhnya.

Trong công việc, phần mà tôi thấy khó chịu nhất mà không thể không làm, là cách một ngày tôi phải dùng tay giúp ông ấy đi cầu. Tuy đã dùng thuốc bơm nước, nhưng thực ra không có tác dụng mấy, vì ông ấy hoàn toàn không đủ sức tự đi ngoài được.

P. 64

Waktu bergulir dengan cepat. Setiap kulihat gedung jam ini, mengingatkanku sudah 12 tahun kuberada di Hongkong. Anda dapat menemukan gedung jam ini di Tsim Sha Tsui. Kini aku berada di Taiwan, dan waktu terus berdetak, menanti waktu akhir aku pulang ke kampung halaman.

Thời gian qua thật nhanh. Mỗi lần nhìn thấy gác chuông này, tôi thường nhớ lại thời gian 12 năm tôi ở Hôngkông. Tiêm Sa Tử cũng có 1 gác chuông giống như vậy. Hiện tại tôi đến Đài Loan , thời gian mỗi phút mỗi giây đi qua, tôi chờ đợi, giống như chạy đua cùng thời gian vậy, đợi cuối cùng cho đến 1 ngày có thể về nhà.

P. 67

Aku bahagia ketika kulihat foto ini. Bukan karena gdeung tertinggi tersebut, namun majikanku sangat mendukungku untuk mendapatkan tempat bagiku untuk berfoto.

Có thể chụp được tấm ảnh này tôi rất vui. Không phải vì tôi chụp được ảnh tòa nhà cao nhất thế giới, mà bởi vì tôi được chủ khuyến khích. Họ đưa tôi đến chỗ này chỉ vì cho tôi tìm được góc độ để chụp tấm ảnh.

P. 68

Ruang perpustakaan umum. Hampir setiap hari aku selalu mendapatkan informasi berita dari sini. Kami juga boleh menggunakan fasilitas computer secara gratis. Petugas perpustakaan juga sangat ramah, membuatku merasa pajak yang kami bayarkan juga sangat bernilai.

Đây là thư viện công cộng. Hầu như mỗi ngày tôi đều đến đây đọc tin tức,rất tiện, nhất là máy ViTính có thể dùng miễn phí, mà còn có nhân viên thư viện rất hiền và gần gũi , những điều này làm tôi cảm thấy chúng tôi đóng thuế rất xứng đáng.

P. 69

Banyak jenis majalah dan koran asal Filipina. Walau harganya tidak murah, namun tanpa membeli mereka, sangat sulit bagiku untuk melewati hari-hari. Karena aku sudah kerasan dengan bahasaku. Kesibukanku membuatku tidak punya waktu untuk belajar mandarin.

Tất cả các loại báo, tạp chí của Philippin bạn có thể tìm thấy ở đây. giá tiền không rẻ, nhưng nếu tôi không mua vài quyển , thì cả tháng rất khó chịu. Bởi vì đây là những dòng chữ ngôn ngữ mà tôi có thể hiểu được, tôi bận đến nỗi không có thời gian học đọc tiếng trung.

P. 70

Seorang TKA gembira berhasil membeli kacang panjang yang mana adalah sayuran khas kampung halamannya. Kini ia tidak perlu lagi terjangkit penyakit rindu kampung halaman.

Một người lao động mua được đậu ngắn cảm thấy rất vui .Cô ấy nghĩ rằng chỉ có ở quê mới tìm thấy loại đậu này. Bây giờ Cô ấy không còn phải sợ vì nhớ món ăn quê hương.

P. 71

April 2005, saat menunggu lampu merah di persimpangan jalan, sebuah mobil melindas jari kakiku. Aku yang masih terkejut tidak sempat melihat plat mobilnya. Untungnya Tuhan masih melindungiku walau setelah kutinggalkan tanah airku, aku sudah tidak berdoa serajin dulu kala.

Tháng 4 năm2005, khi tôi đứng ở ngõ phố này đợi đèn đỏ, 1 chiếc xe lăn qua ngón chân tôi. Làm tôi giật hoảng hốt tôi cũng không nhớ được số xe ,Vẫn còn may tôi không bị thương hay bị đau.Cảm ơn Thần đã cùng đồng hành với tôi,thực là sau khi tôi rời khỏi Philippin thì không còn thành kính như trước.

P. 72

Foto ini adalah foto pribadiku sebagai seorang seniman. Hobby melukis dan menggambar telah membuat aku dapat menghasilkan uang dan sekali lagi menolongku ketika lapar dan tidak punya uang saat menunggu proses untuk bekerja di Taiwan. Kemanapun aku pergi, semua alat-alat ini akan selalu berada di sampingku.

Tôi nghĩ Bức ảnh này là một bức vẽ người của nhà nghệ thuật gia. Vẽ tranh và phác họa tranh là sở thích và cũng là kỷ năng mưu kế sinh nhai của tôi. Tất cả những tích lũy tôi dùng vào việc làm thủ tục xin đến Đài Loan làm công, nhờ vào kỷ năng này tôi mới tránh được bị đói.Bất luận đến nơi nào, những bức tranh này không thể tách rời tôi ra được.

P. 73

Bagiku, ini adalah tanda persahabatan.Ibarat aku dan temanku, kami suka mengenakan pakaian atau sepatu seperti ini.

Đối với tôi mà nói, đây là sự tượng trưng thân mật của tình bạn.
Cũng giống Tôi và bạn tôi, Chúng tôi thích mặc cùng 1 kiểu quần áo hay dép mang giống nhau.

P. 74

Wanita ini adalah pekerja asal Filipina yang mendapatkan pemasukan ekstra dari memberikan jasa mengecat kuku di sisi jalanan Chung Shan North Road

Đây là người phụ nữ di dân Phillippin, Cô ấy ở đường Bắc Trung Sơn trên đường dành cho người đi bộ làm nghề phục vụ cắt sửa làm đẹp móng tay móng chân kiếm thêm ít tiền ngoài

P. 75

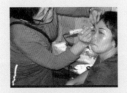

Seorang Filipina mendapatkan tattoo alis hanya dengan 100 dolar saja. Namun aku tidak pernah menginginkannya.

Có 1 người Philippin đang xâm chân mày, chỉ cần 100 đồng thì có thể làm được, nhưng tôi không muốn thử.

P. 76

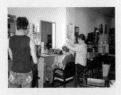

Seorang pekerja Filipina membersihkan rambutnya di salon agar terlihat cantik, walau hanya di hari Minggu saja.

Một người lao động Philippin đang trong tiệm gội đầu, mong cho mình đẹp 1 tí, cho dù chỉ trong ngày chủ nhật thôi.

P. 77

Sol sepatu harus pilih yang tinggi untukku jika ingin terlihat lebih tinggi.

Mang dép cần cao 1 chút như vậy tôi cảm thấy mình cao hơn.

P. 79

Ini adalah gaya kami duduk di depan meja. Dari kiri adalah majikan, aku, akong dan ama. Majikan dan pegawai harus berbeda posisi.

Đây là vị trí trên bàn ăn chúng tôi. Từ trái sang phải: Bà chủ , tôi, Ông cụ, Bà cụ . Người mướn và Chủ có sự phân đẳng cấp khác biệt.

P. 80

Meja yang sederhana dalam disainnya namun harganya selangit. Suatu ketika ada benda yang jatuh di atasnya dan merusak permukaan meja. Majikan menanyakan apakah aku tahu harganya. Ia menjawab: harganya sama dengan 2 tahun lebih 2 bulan gajiku. Jawaban majikan terus terngiang di telinga dan membuatku terus memikirkannya selama 1 bulan lebih.

Cái bàn này hình dáng đơn giản nhưng rất đắt tiền làm tôi thấy lo lắng. Có bận, bị đồ vật rớt xuống mặt bàn, bà chủ hỏi tôi , có biết cái bàn này giá bao nhiêu tiền không. Bà ấy nói: bằng 2 năm cộng thêm 2 tháng lương của tôi. Câu nói này tiếp tục bên tai tôi, hơn cả tháng, làm tôi suy nghĩ mãi về chuyện này.

P. 80

Sidik jari adalah salah satu bentuk bukti dalam kasus. Semula aku tidak percaya, namun sekarang sidik jari di atas meja benar-benar nyata. Kini setiap kali berhubungan dengan benda yang mahal, aku pasti akan berusaha untuk menghapusnya.

Có một số sự kiện , dấu tay được dùng làm bằng chứng . Trước đó tôi không tin chuyện này . Hiện giờ thì cái bàn này đã chứng minh việc tồn tại của dấu vân tay .Vì thế khi đối diện những vật đắt tiền , tôi học được cách thức luôn lau chùi sạch sẽ.

P. 81

Aku suka menggunakan wastafel yang semula tidak memiliki gantungan apapun. Suatu hari majikan menemukan aku menggantungkan gantungan baju diatasnya. Keesokannya sudah terpasang bebek-bebek karet ini.

Tôi thường dùng bồn rửa mặt này, trên mặt bồn thường không có để một vật gì. Có lần tôi lấy quần áo phơi trên giá tạm thời móc ở đây. Chủ tôi nhìn thấy , cách hôm sau liền xuất hiện những con vịt nhựa đặt ở đấy.

P. 81

Setiap kali selesai bekerja di dapur, aku akan beristirahat di dalam kamar mandi. Duduk di atas sandal, kadang menulis surat, membaca koran atau mendengarkan radio Hello Taipei. Aku melakukan semua itu di sini.

Mỗi buổi tối kết thúc công việc nhà bếp , tôi thường ở trong phòng tắm nghỉ 1 chút. Ngồi trên đôi dép, có khi viết thư hoặc có khi bên đọc báo ,bên mang phone nghe đài phát thanh " Chào Đài Bắc " , có lúc tôi cũng gọi điện thoại. Thường thì những việc này tôi làm ở đây.

P. 82

Foto ini diambil pada hari Minggu, ini juga menjadi alasan mengapa sapu-sapu ini dapat berada dalam keadaan istirahat.

Đây là tấm ảnh chụp vào ngày chủ nhật, đó cũng là tại sao mà những cay chổi đều trong trạng thái nghi ngơi.

P. 84

Orang Taiwan memiliki kartu tanda penduduk dan kartu kredit; TKA memiliki kartu ARC dan kartu ATM, yang berbeda adalah: kartu yang kami pergunakan ada batas penggunaannya.

Người Đài Loan có giấy chứng minh nhân dân đài loan hoặc thẻ tín dụng; Dân lao động chúng tôi có thẻ cư trú và thẻ rút tiền. Có 1 điều khác nhau là quyền sử dụng của chúng tôi bị giới hạn

P. 85

TKA di belakang gerbang meminta temannya di luar untuk membantu mengirimkan uang, karena ia tidak dapat libur. Di sini, kebebasan memiliki arti yang berbeda.

Người lao động đứng bên trong cánh cửa khóa đang nhờ các bạn bên ngoài giúp cô ấy việc chuyển tiền, bởi vì cô ấy không được nghỉ phép ra ngoài. Ở nơi này, định nghĩa về tự do có khác.

P. 86

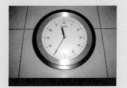

Temanku bercerita, majikannya sangat loyal, baik dalam hal baju, uang dan lain-lain. Namun pelit dalam hal waktu libur, juga tidak pernah boleh terlambat dalam waktu kerja.

Bạn tôi nói với tôi , có nhiều việc chủ của cô ấy rất rộng rãi , ví dụ như quần áo, tiền bạc..vv... Nhưng đối với thời gian thì không rộng rãi 1 chút nào, rất nghiêm khắc ngay cả thời gian nghỉ ngơi hay nghỉ phép .Riêng công việc thì nhất thiết phải nhớ là đừng đến trễ giờ.

P. 88

Ini adalah mejaku, tempat aku sarapan, makan siang dan malam. Aku tidak boleh makan bersama mereka di ruang makan.

Đây là bàn ăn cơm của tôi; Ở đây tôi ăn sáng, cơm trưa và cơm tối. Tôi không thể cùng họ ăn cơm nơi họ dùng cơm.

P. 90

Ketika menggunakan kompor gas tua ini, aku selalu takut kemungkinan akan mele-dak. Namun aku tetap bahagia, karena majikan mengijinkanku untuk memasak.

Lúc tôi nấu thức ăn trên cái bếp ga củ kỷ này, tôi thường lo ngay ngáy, sợ nó nổ bất cứ lúc nào. Nhưng tôi vẫn cám ơn Ông chủ, bởi vì Ông ta cho phép tôi được nấu ăn ở đây.

P. 92

Gelas di rak atas adalah milik majikan. Aku juga punya milikku, disediakan oleh majikan sebelum aku datang. Aku tahu batas teritorial daerahku.

Ly ở tầng trên là của Chủ tôi. Tôi cũng có của tôi, Chủ mua cho tôi trước khi tôi đến. Ít nhất tôi biết phạm vi của tôi ở đâu.

P. 93

Ketika semua orang berada dalam rumah, aku lebih suka menggunakan meja ini untuk makan dibanding dengan meja makan umum. Aku merasa lebih leluasa. Setiap ada kesempatan, aku berusaha untuk menjaga jarak dengan mereka guna mengingatkan posisiku dan sikap rendah diri.

Lúc mọi người đều ở nhà, Tôi chỉ muốn dùng cái bàn này ngồi ăn cơm ,tôi không thích ngồi ở bàn lớn ăn cơm, như vậy tôi cảm thấy thoải mái hơn .Thường thì tôi cố giữ khoảng cách với chủ 1 ít.Tôi tự biết vị trí của mình, và hy vọng lúc nào cũng giữ khoảng cách thấp ấy.

P. 94

Setiap aku sakit, majikan berprediksi bahwa aku ditularkan dari teman di luar dan harus mengenakan masker. Namun ketika mereka sakit, alasannya karena pengaruh cuaca dan tidak perlu mengenakan masker.

Khi tôi bị bệnh, chủ tôi cho là tôi bị bạn ở bên ngoài lây nhiễm và bắt tôi phải mang khẩu trang. Khi họ bị cảm, họ thường nói là do chuyển đổi thời tiết, mà chẳng khi nào thấy họ mang khẩu trang cả.

P. 95

Di Taiwan semua orang punya kebebasan untuk berpakaian walau ada yang menatap dengan pandangan aneh. Namun sebagai seorang TKA yang bekerja di rumah tidak boleh sembarangan berpakaian. Terlampau sexy akan menjadi alasan terjadinya kasus pelecehan seksual atau pemerkosaan.

Ở Đài Loan mọi người có quyền chọn lựa ăn mặc tự do, cho dù có thể là bị nhòm ngó. Người lao động chúng tôi mặt này thì không được tự do, Nhất là đối với lao động giúp việc.Nếu mặc quần áo lộ liễu 1 chút, rất dễ bị quấy nhiễu tình dục , thậm chí trở thành lý do bị xâm hại tình dục.

P. 103

Jangan berprasangka bahwa ini adalah hari Natal atau hari kasih sayang. Masyarakat Taiwan yang mengenakan baju merah berkumpul bersama untuk menyuarakan isi hatinya. Berapa lama protes "Bian turun" akan terus berlangsung? Namun presiden Chen masih saja terus berada di sana.

Đừng nghĩ đây là Lễ Giáng Sinh hay là Tết Tình nhân. Đây là những người Đài Loan mặc áo đỏ tập hợp với nhau đi gào thét sự tức giận của họ. ' Lật 扁 ' không biết cuối cùng còn phải kéo dài bao lâu ? mà Tổng thống Trần vẫn còn đó.

P. 104

Wow, hebat! Anda dapat menemukan sayur yang ditanam dalam pot. Walau tidak memiliki lahan untuk menanam, namun masih ada jalan lain yang dapat dipergunakan.

A, tốt quá, nhìn thấy trong chậu trồng rau.Dùcho không có vườn hay đất , gia đình này cũng cách có thể trồng rau.

P. 105

Kami sebut pohon ini "Balite". Ada kepercayaan di Filipina yang menyebut bahwa pohon ini dapat memanggil arwah. Itu juga alasannya mengapa pohon seperti ini hanya ditemukan di dalam hutan dan tidak di pinggir jalan seperti ini.

Chúng tôi gọi loại cây này là Balite. Philippin theo cách nói mê tín là loại cây này gọi ma . Đây là lý do tại sao chỉ ở rừng chúng tôi mới nhìn thấy loại cây này, không bao giờ thấy chúng mọc bên vệ đường.

P. 106

Di luar kota, anda harus mengerti bahasa dan tulisan mereka, jika tidak maka anda akan tersesat. Tidak seperti di kota Taipei, yang pasti ada terjemahan dalam bahasa Inggris.

Ở khu vực ngoài thành phố, nếu bạn không biết chữ , chắc chẳn bạn sẽ bị lạc. Không giống trong thành phố, tên phố họ có phiên dịch bằng tiếng anh.

P. 107

Lelaki tua di daerah Ximenting yang sibuk memeriksa produk tali sepatu yang dijualnya. Walau hanya menjual barang yang murah, namun ia tetap mengenakan stelan jas yang membuat orang terpesona. Lelaki tua yang istimewa, setiap orang seharusnya melihat bahwa ia punya sisi yang sangat indah.

Ở Đinh Môn Tứ có một ông già đang cẩn thận kiểm tra những dây giày ông đang bán . Tuy chỉ là những đồ rẻ tiền , nhưng ông mặc âu phục làm cho người ta cảm thấy dáng vẽ không tệ , một ông già đặc biệt, mọi người đều chú ý đến cái vẽ đẹp đặc biệt đó của ông.

P. 108

Saat membayar, aku baru menyadari jika tahun nya terlambat 11 tahun. Misalnya 28 September 2006, maka di Taiwan akan ditulis 28 September 1995

Lúc kết toán sổ sách, tôi phát hiện ngày tháng của Đài Loan trễ hơn so với Philípin 11 năm, Ví dụ như ngày 28 tháng 9 năm 2006 thì Đài Loan là ngày 28 tháng 9 năm 1995.

P. 109

Kotak pos adalah fasilitas yang terbaik. Anda tidak perlu selalu pergi ke kantor pos, apalagi bagi yang sibuk. Di Filipina tidak memiliki sarana seperti ini, dan kami harus langsung pergi ke kantor pos.

Gắn thùng thư rất tốt, bạn có thể không cần phải đến bưu điện gửi thư, đối với những người bận nhiều việc thì rất tiện. Ở Philippin chúng tôi phải trực tiếp đến Bưu điện mới có thể gửi thư.

P. 110

Mereka menggunakan balok batu untuk membangun rumah. Di Filipina, kami menggunakan kerikil dan juga pasir.

Họ dùng gạch viên xây nhà. Ở Philippin chúng tôi dùng đá xây và cát xây nhà.

P. 111

Aku selalu takut melihat orang yang memiliki tattoo di badan. Di negaraku, biasanya orang-orang seperti demikian adalah langganan penjara.

Nhìn thấy trên người khác xâm mình tôi rất sợ. Ở quê tôi, những người trên lưng có xâm hình ,thường là những kẻ tội phạm vô tù ra khám.

P. 112

Inilah cara mereka menyajikan makanan yang jelas berbeda dengan di Filipina.

Đây là cách thức họ chuẩn bị thức ăn cho buổi tổ chức hoạt động lớn , hoàn toàn không giống ở Philippin.

P. 113

Kebiasaan kami makan saat berada di Phillipina adalah dengan tangan atau kadang dengan garpu dan pisau, namun masyarakat Taiwan menggunakan sumpit. Dan akhirnya kutemukan lebih mudah makan mie dengan menggunakan sumpit.

Thói quen của người Phillipin là dùng tay hoặc dao nĩa ăn thức ăn. Người Đài Loan có thói quen dùng đũa .Tôi phát hiện dùng đũa ăn mì thật đúng là vừa đơn giản vừa nhanh.

P. 114

Di Taiwan sangat modern, orang menjual es krim dengan motor. Di Filipina, orang menggunakan gerobak dorong.

Kỹ thuật buôn bán nhỏ về kem ở Đài Loan rất cao, họ dùng xe moto chở kem đi bán. Ở Philippin tiểu thương họ dùng xe đẩy.

P. 115

Anak yang lugu dan polos bermain di jalanan. Tidak ada yang menjaganya karena sang ibu sibuk jualan sarapan. Sama halnya dengan anak-anak pekerja asing, tidak ada yang menjaga, mudah menjadi anak yang bermasalah kelak.

Một đứa trẻ ngây thơ đang chơi bên lề đường, không có người trông, vì mẹ em đang bận bán đồ ăn sáng , giống đứa trẻ lao động, không có Ba Mẹ bên cạnh , dễ sinh ra vấn đề trẻ nghịch bướng.

P. 116

Nomor yang berlainan mengindikasikan jurusan bus yang berbeda pula. Di negara kami, kami menggunakan nama tempat tujuan sebagai pengganti angka.

Xe không cùng số , cho biết xe chạy các tuyến đường không giống nhau. Xe công cộng ở nước tôi không có mang số, Chúng tôi dựa theo các biển hiệu chỉ địa điểm.

P. 117

Di Taiwan, banyak perusahaan taxi namun hanya memiliki satu warna, yakni kuning. Sehingga masyarakat dapat dengan mudah mengenalinya dari jauh. Di Filipina, anda boleh memilih warna sesuka hatimu.

Đài Loan có rất nhiều xe Tacxi, nhưng xe chỉ có 1 màu vàng. Vì thế nên dù ở khoảng cách xa rất dễ nhận ra. Ở Philippin, Bạn có thể chọn bất kỳ xe màu gì bạn thích.

P. 118

Aku terpesona dengan desain unik iklan yang menggunakan tangga. Aku tidak pernah melihat gaya disain seperti ini di Manila.

Đây là cái cầu thang được thiết kế rất đặc biệt làm tôi khó quên, vì nó được thiết kế để làm quảng cáo, Tôi không biết nơi nào ở Manila đã nhìn thấy thiết kế như vậy .

P. 119

Ini adalah salah satu tradisi Taiwan yang tidak dapat saya mengerti, dan sepenuh-nya berbeda dengan yang berada di negaraku.

Đây là một hoạt động mang phong tục dân tộc truyền thống của Đài loan, nhưng hiện tại tôi vẫn chưa tìm ra sự quan hệ ra đời của nó. Truyền thống Đài loan như vậy so với truyền thống quê hương tôi khác rất nhiều.

P. 120

Yang tercinta Jen. Hari ini adalah hari Minggu, pesawat yang kutumpangi akan siap berangkat. Ini adalah pengalamanku yang pertama. Saat aku berada di angkasa, aku terus memikirkanmu dan keluargaku. Aku rindu kalian semua dan berharap kamu tetap akan sama seperti dulu ketika kukembali nanti. Aku tidak tahu apa yang menantiku di Taiwan. Apakah aku akan mendapatkan majikan yang baik? Atau seorang majikan yang terus melototiku dan mempekerjakanku ibarat mesin? Banyak pertanyaan. Namun aku tidak pernah akan lupa berdoa kepada Yang Maha Kuasa untuk perlindungannya bekerja di negeri orang.

Jen thân yêu, hôm nay là ngày chủ nhật, Tôi ngồi chuyến bay này đúng giờ cất cánh. Lần đầu tiên tôi có cảm giác như vậy , nói không nên lời cảm giác như thế nào . Khi máy bay ở trên cao, tôi nghĩ đến tôi vẫn còn có người thân. Tôi sẽ luôn nghĩ đến mọi người.Chỉ hy vọng khi tôi trở về Bạn vẫn là bạn như ngày nào.Tôi không biết khi đến Đài loan sẽ gặp chuyện gì. Chủ của tôi có tốt không? Hay là gặp phải người chủ để cho đói, xem tôi như cái máy làm việc? rất nhiều rất nhiều nghi vấn.Nhưng tôi sẽ không quên cầu Trời bảo hộ cho tôi nơi đất nước xa xôi này.

P. 121

Setibanya aku, kulihat gedung tinggi dimana mana dan juga jalanan tol yang ber-beda dengan negara kami. Jika perekonomian Phillipina baik, aku pasti tidak akan mengambil resiko untuk bekerja di luar negeri.

Lúc đáp máy bay, tôi nhìn thấy những lầu cao mọc chi chít như rừng. những con đường cao tốc dài ngoẵng không giống ở đất nước của tôi.Nếu kinh tế Philíppin không gặp khó khăn, thì làm sao tôi phải rời quê hương để đối diện với biết bao nhiêu điều mà tôi còn bỡ ngỡ.

P. 122

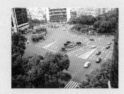

Yang tercinta Hazel dan Herd, ketika aku masih terasa asing di kota Taipei, majikanku memintaku berjalan-jalan untuk mengenal tempat ini.

Hazel và Herd thân yêu, khi chúng đối với Đài Bắc còn lạ lẫm, Chủ tôi muốn tôi đi đến những nơi xung quanh gần đó để làm quen nơi này.

P. 122

Suatu hari majikanku menelepon dan meminta aku untuk memasuki sebuah toko, ternyata itu adalah sebuah toko perhiasan.

Có 1 ngày Chủ tôi gọi điện thoại kêu tôi đi đến 1 tiệm, là tiệm bán đá ngọc quý.

P. 123

Ketika sedang berjalan, sebuah toko sepatu menarik perhatianku, Royal Elastic Shoes. Ada sepasang sepatu model terbaru, namun akhirnya aku memutuskan untuk tidak masuk, karena uangku belum cukup.

Đi trên phố, có 1 tiệm làm tôi chú ý, Đó là tiệm bán dép, hiệu ROYAL ELASCTIC SHOES. Trong tiệm đều là những mặt hàng kiểu mới, nhưng tôi không thể vào xem kỹ , vì tôi vẫn chưa đủ tiền để mua.

P. 123

Sejak saat itu, setiap melewati tempat ini, aku selalu berdoa: suatu hari kelak, sebelum aku pulang rumah, aku akan membelikan kalian masing masing satu pasang sepatu baru.

Bắt đầu từ ngày đó , mỗi lần đi qua nơi đây, lòng tôi tự nhủ: có một ngày trước khi tôi về nước, nhất định mua cho mỗi người 1 đôi. Trước khi đến ngày đó , phải nên tự lo chăm sóc mình .

P. 124

Ini adalah protes kami terhadap kasus " Fastfame" hingga akhirnya ditutup. Mereka berhutang 3 bulan gaji kepada kami. Ini adalah awal pertemuan kami dengan TIWA.

Đây là sự kiện Công xưởng " Phi minh " .Công xưởng thiếu tiền lương Chúng tôi 3 tháng liền, dẫn đến việc chúng tôi phải đấu tranh cho đến lúc công xưởng đóng cửa. Đây cũng là sự kiện khởi sự đưa chúng tôi kết duyên với " Hội trợ giúp lao động Quốc Tế " .

P. 125

Ini adalah tempat kerjaku yang lama. Setiap saat kumelewatinya, terkenang masa pahit perjuangan dengan " Fastfame " . Hal ini telah menimbulkan trauma bagi setiap pekerja " Fastfame" .

Đây là nơi chúng tôi làm việc trước đây.Mỗi lần đi ngang qua đây làm tôi nghĩ đến những thử thách khó khăn của ngày đấu tranh. Đã để lại bóng đen trong lòng của mỗi công nhân công xưởng 'Phi minh' này.

P. 125

Asrama tempat tinggalku di " Fastfame" lantai 4. Walau hanya sebuah gedung tua dan harus naik tangga setiap kali pulang, namun kami selalu merasa senang dan bahagia.

Đây là ký túc xá của công nhân " Phi minh " ở lầu 4. Chúng tôi đều phải đi cầu thang bộ . Một nhà lầu vô cùng củ xưa , nhưng ở đây chúng tôi đã sống qua những ngày tháng vui vẻ.

移工攝影師
Migrant Photographers

Alicie E. Dimzon
阿麗絲・汀森

I am Alice Dimzon, I was employed by Fast Fame Technology Inc., as a factory worker in Sanchung, Taipei.

I enjoyed my work there and took things so easy, until we got a problem. Our factory is about to bankrupt and he owe us three month of unpaid wages. We fight until the company closed with the help of Taiwan International Workers Association (TIWA), then I was transferred to a new factory in Wuku, and go on with my life here in Taiwan.

After the Fast Fame struggle, I was inspired to join in Kapulungan Ng Samahang Pilipino (KASAPI). KASAPI is a group of Filipino migrants——Taiwan based.

Right now, I am here not only as Filipino worker who aspires for a better future for my family but also give support to my fellow migrants.

我叫阿麗絲‧汀森。我是台北三重飛盟國際的廠工。

　我喜歡那裡的工作，工作很順利，直到我們遇到一個麻煩。我們的工廠面臨倒閉，積欠了我們三個月的薪資。在台灣國際勞工協會幫忙下，我們持續抗爭，直到工廠關閉。然後我被轉到一個在五股的新工廠，繼續在台灣的生活。

　飛盟的抗爭活動啟發了我參加菲律賓移工團結組織（KASAPI），這是一個在台的菲律賓外勞組成的團體。

　現在，身為一個在台灣的菲律賓移工，我不僅為家庭的美好未來奮鬥，也為其他移工盡一己之力。

翻譯：Yen-ling Chen

Blesilda Candingin
布蕾西達・坎汀寧

I'm Blesilda Candingin, a caretaker, like most other migrant workers. I cross land, bridges in search of green without knowing what awaits me in foreign land. Working overseas is like setting foot on the battle field, win or lose is the game. The fortunate one may find the green pasture and reaped the fruit of their hard earned labor. But for the unfortunate one, sad to say, will go home penniless. Luckily, I could say that I belong to the former. However, I also encountered roadblocks along the way. While I was struggling, I told myself that I should find ways to divert my idle time into meaningful and productive way to release my pressure and tension and homesickness. That's how I began to engage myself in different Pilipino organizations including the Kapulungan ng Samahang Pilipino; Samahang Makata (association of poets and writers) and TIWA.

In TIWA and KASAPI, I got deeply involved in various activities/projects that concern the welfare of migrant workers. Through these organizations, I found a second home and learned a lot of things that changed my philosophy in life.

I've been here in Taiwan for almost six years. It is a great honor to have

the opportunity to devote myself to the welfare of migrant workers, and the experiences also benifit my personal growth.

Before I joined this photo workshop, all I know is to say to whoever is photographing me to "make it beautiful" without knowing much about the concept and technique of what a powerful photograph is about, such as the precise moments, special angles, movement and counter-movement, etc. Thanks to our generous teachers for sharing their knowledge. Now I think I am well-equipped and ready to face the reality of photography.

在台灣，我是個看護工。我千里跋涉想要尋找一片綠蔭草地，卻對在異鄉等待我的一切一無所知。到海外工作就像涉足一場戰役，難知輸贏。對一些幸運兒來說，他們可以尋找到那片綠地，辛勤勞動以收割豐富的果實。然而對那些不幸者來說，最後可能落得返鄉時身無分文。我可以說自己是屬於幸運的那一群人，但這一路上我也不是沒有遇過困難。我一度想要打道回府，面臨掙扎的時候，我告訴自己與其把時間花在胡思亂想上，倒不如用些有意義和生產力的方式來處理我的壓力、緊張和鄉愁。所以我開始參與不同的菲律賓人組織，包括菲律賓移工團結組織（KASA-PI）和菲律賓海外詩人作家協會（Samahang Makata）還有台灣國際勞工協會（TIWA）。

在TIWA和KASAPI，我相當深入地參與了各項關於移工權益的活動與計畫。在這些組織當中，我彷彿找到了第二個家，並且學到許多改變我生命哲學的事情。我在台灣已經近六年了，投入移工權益的服務對我而言是無上的光榮，我也從中得到使自己人格成長的好處。

在我參加這個攝影工作坊之前，我唯一知道關於照相的事就是告訴照相的人把我照得美美的，而不會去注意到原來要照出好相片還涉及到技術問題，包括取景的角度、動態、取景的時點的精準等等。對此要感謝我們體貼又傾囊相授的講員們，現在我已經具備足夠的攝影知識，準備進入實戰階段了！

翻譯：黃于玲

Cyd Charisse B. Sannoy

雀芮絲・薩諾依

I am Charisse. I came from the Central Visayas region of the Philippines. I have been working here as a caretaker for 18 month, and this is my first time working abroad.

My first year here was never easy for me. I never had an official holiday off for a year as per contract, so I needed to face all the challenges by myself: different kinds of job; different people to work and to live with; different climates——the harsh cold winter in particular; and very limited friends to talk to. But with my prayers and fighting spirit, I made it through all these struggles. Now, my life is better than before. I have monthly day-offs which makes possible for me to work and enjoy my stay here at the same time.

When I first heard about TIWA's photo workshop, I was excited yet hesitate to sign up because the class is scheduled on Sundays yet my usual day-offs fall on Saturdays. I really wanted to get in so I went and talked to my boss and fortunately she was nice enough to allow me to attend the class.

I never had any professional experience as a photographer before I joined the class. I learned a great deal in the workshop, especially the do's and don'ts of the act of photo-taking. I never thought that pictures can talk, not until

our instructors taught us how to make an ordinary scene into a more interesting one, which I'd say, is really worth the time and efforts to practice. Other than leaning photography, I also got to meet people and made friends in the classroom. This workshop made us become more attentive and mindful to the places, the people and the culture of Taiwanese. Of course it wasn't easy for us taking part of this class because the instructors would challenge us with various assignments and we needed to work and pass every time as part of our training.

Now as our photography class has come to its end, I (and the rest of my classmates I believe) can assure the TIWA that we are taking this workshop very seriously and that we are grateful for the opportunity given to us. The efforts, a lot of them, we put into our works are good enough to prove our interests and seriousness.

　　我是雀芮絲，我來自菲律賓菲撒雅斯群島（菲撒雅斯群島是菲國三大群島之一，在呂宋群島南方）。我在台灣做看護工已有18個月，這是我第一次出國工作。

　　剛來的第一年真是不適應，因為一整年連契約中明訂的國定假日休假，都不能休一天。所以我得靠自己去面對所有工作的挑戰：不同的工作、新的照顧對象、無法忍受的冬天、沒有講話的朋友。不過，靠著祈禱跟奮戰精神，這些苦我都熬過來了。現在生活比以前好多了，我每個月都有假日，所以我能夠一面工作一面享受待在這裡的日子。

　　我的假日都在禮拜六，為了參加攝影課，我試著向雇主爭取禮拜天休假，沒料到她很好心地答應了讓我去參加工作坊。參加這個工作坊之前我一點專業訓練也沒有。而我在這個課上學到好多東西，像是拍攝時該做和不該做的事。之前我從來沒想過照片會說話，直到工作坊講員教我們如何把一張無聊的照片變得對觀眾有吸引力，我才領會為什麼這個課對我跟其他每一個學員而言，這麼值得我們投入時間跟心力。而且，我不僅學到經驗還交到朋友，而且還認識好多不同的人。攝影工作坊也讓我們更加用心關注周遭空間、人、以及台灣文化。當然完成這個課程本身也不容易，因為每次講員給的作業都有種種挑戰，而我們得一一過關才算完成這項訓練。

　　現在攝影工作坊結束了。相信台灣國際勞工協會可以看到我們在攝影課中一路走來的認真，還有我們對擁有參與工作坊的這個機會的感激。從我們在作品中的用心，應該可以看出我們的興致與認真。

翻譯者：王品

Edcel Regalario Benosa
愛契・瑞卡拉瑞爾・貝諾莎

My name is Edcel Regalario Benosa, I was born on December 24. 1978. I'm 27 years of age. My home town is Cabariwan Ocampo. Camarine sur, Philippines. My father's name is Eduardo Benosa and my mother's name is Marcelina R. Benosa. In my family, I have ten sibling, I'm the six of them.

I graduated my elementary grade at Ocampo central school in Camarine sur, and I finished my high school at Ocampo National High School, also in Camarine sur. I also a leader in my town (youth organization). Because of poverty, my parents is not able to support us to study in college, I decided to worked overseas to helped my younger brother and sister to go to school. I sacrifice my self to worked in abroad as a caretaker to help also my family needs.

Here in Taiwan , I'm a vice-chairperson of the OFE Family Club Taiwan Chapter. First to being unite the migrants and to help or to give some advice if they have a problem, especially to all the Filipinos. And I tried also to joined in the contest, (Poetry Writing Competition) successfully won the First Prize last August 4. 2006. with Ma Ying Jeou, the Mayor in Taipei. And now, I currently joined the photo workshop, conducted by Taiwan International Worker Association

(TIWA) . On July 2007, I finish my contract in three years here in Taiwan. And I hope my employer does not change for another 3 years left.

　　我的名字是愛契・瑞卡拉瑞爾・貝諾莎，1978年12月24出生，今年27歲。我的家鄉在菲律賓卡巴瑞灣歐卡波省的卡瑪瑞蘇市，我父親的名字是愛督爾多・貝諾莎，母親則是馬契麗娜・貝諾莎，我家總共有十個兄弟姊妹，我排行老六。

　　我小學畢業於卡馬瑞蘇的歐卡波小學，中學則畢業於一樣在卡馬瑞蘇市的歐卡波高中。我同時也是我家鄉（青年組織）的領導者。因為貧窮的緣故，我的父母沒辦法資助我們念大學，我為了讓年幼的弟妹上學，決定到國外工作。我犧牲自己到國外做照護工作，以幫助家庭的需要。

　　在台灣，我是海外菲律賓家庭社團（OFE Family Club）台灣分會的副主席，主要的工作是組織移工以及在他們有問題時給予幫助和建議，特別針對菲律賓移工。我曾經參加比賽（『台北詩文比賽』），順利獲得第一名，並於2006年8月4日接受台北市市長馬英九的頒獎。現在，我加入了由台灣國際勞工協會（TIWA）所組織的攝影工作坊。2007年7月，我在台灣的三年合約就到期了，我希望我的雇主會繼續雇用我。

翻譯：陳秀蓮、郭耀中

Elizabeth R. Dela Cruz
依麗紗白・德拉・庫魯斯

I am Elizabeth R. Dela Cruz, a farmer, the third and only girl in five siblings.

Living across the sea for almost half of my life, I have already compared the situation of Filipinos working here from our country. I was once a community organizer in our province, where poverty and corruption are everywhere. Binding with the same goal, we fight against the wrong implementation of tax. We helped many small farmers to appeal against the unequal income distribution between the owner and the farmer of the land. We expressed our minds against the wrong settlement of land reformation through demolition. Hope that way, we could give justice to the unsystematic treatment against the laborers. This experience gave so much impact in my life.

Now as a migrant worker here, everything was just the same, though here, we exercise caution carefully. Racial discrimination is everywhere. Our freedom to express ourselves is minimal. Seeking for justice in our land was so difficult. How much more if you are in a place where everybody treats you as an alien. Chances are only silence and sacrifice. Because from what I saw before

from our country, up to the very moment right here, there had never been any changes. From the highest degree to the lowest one, you're still a laborer, and you are to be treated like one.

Witnessing how many decades evolution of this world, life taught me one thing. "Life is never fair, it's how you take it." Man will eat you alive to survive. If you are weak, learn to be strong. Fight to the extent of not knowing how to win. Never give up, as long as you still have a chance. This is the essence of existence.

我是依麗紗白・德拉・庫魯斯，家裡務農，在五名小孩裡排行老三，是唯一的女孩。

我在海的另一端過了大半生，這讓我對菲律賓和台灣的生活差異感觸良多。在菲律賓我是一個社區組織者，在我住的省分，貧窮和貪污隨處可見。我與一群志同道合之士並肩作戰對抗錯誤的賦稅制度，我們並協助弱勢小農挺身而出，反對偏袒地主的所得分配體制。透過破壞的手段，我們表達我們對倒行逆施的土地改革的心聲。希望透過以上種種作為，我們能為備受忽視的工人帶來些許正義。這些經驗對我造成很大的影響。

在台灣身為移工，我看到的一切與以前相較幾乎沒有改變，唯一的不一樣是在這裡凡事必須小心翼翼。種族歧視隨處可見。言論自由是奢侈的。在這片土地尋求公平正義是多麼困難。還有什麼比得上你處在一個所有人都當你是局外人的地方？多半時候你只能沈默與犧牲。無論我在母國或在這裡，事情從來沒有改變。無論用哪一個標準來衡量，你都只是一個工人，而別人也這樣對待你。

旁觀幾十年來世局的變革，生命教會我一件事：「生命永遠是不公平的，端看你如何接受它。」為了生存，別人會把你生吞活剝。要是你太虛弱，請學會堅強。要奮鬥到最後一刻，直到無計可施為止。只要有一絲機會，就別輕言放棄。這便是存在的本質。

翻譯：維菁

Ellen R. Panaligan
愛倫・帕娜黎根

I'm ELLEN R. PANALIGAN, a domestic helper here in Taiwan. I came here from year 2001. I am a single mother with two daughters, Reandel and Milfean Joy, they are my inspiration in life.

As a domestic helper, I am lucky to have a good employer which I consider as the blessing from God.

Why do I come to Taiwan? I wanted to have a better future and to earn more money for my family. I know in life we all take chance. Coming here to Taiwan was a risk. It is like going through a dark tunnel and not knowing what lies ahead, not knowing what's inside. But I hold God's promise that he has plans for each one of us. He provides for our needs.

I have three best things have happened to my life after years of my hard work and sacrifice here in Taiwan. First, being able to buy a house and lot. My family used to live in a rented NIPA house. Secondly, I am able to give my two daughters a good education. I will continue to work abroad until my daughters finish their schooling. Winning the FIRST PRIZE in POETRY WRITING last year(2005) is the third best thing happened to me and I dedicated my success to my father. I won in the Poetry contest in three consecutive years, from 2003

to 2005. Poetry gives me a very meaningful and colorful life here in Taiwan. I love writing poem and essays, artwork, designing and flower arrangement. These are the talent that God gave to me and I consider it's the best gift from God. I write poem while doing housework; I could be mopping the floor when an idea strike me. Therefore, I keep a piece of paper and pen ready all the time.

I have joined many activities here in Taiwan. I grow and learn from all the activities and organizations, the memories that I will cherish forever. Participating the photo workshop is a great opportunity for learning and experiencing as a migrant like me. It's very educational, interesting and useful.

Thank you very much!

　　我於2001年來到台灣從事家庭幫傭工作。我是一個單親媽媽,我的兩個女兒——Reandel和Milfean Joy——是我生命的靈感。身為家傭,我很幸運地擁有一位好雇主。我認為這是上帝的恩賜。

　　為何來台灣?因為我想要在未來有更好的生活,為我的家人賺更多錢。我知道我們的生命充滿了冒險,而前來台灣也具有風險;就像穿越一個黑暗的隧道,不知道隧道裡有什麼,也不知道盡頭是什麼樣。但我相信上帝對每個人都有祂的計畫,祂提供我們所有的需要。

　　在台灣辛苦工作、犧牲奉獻多年之後,有三件最美好的事情發生在我身上。第一件事是我有足夠的能力買了一間房子和一塊地。我的家人原本居住在租來的茅草屋,現在終於有了自己的房子。第二件事是,我能夠提供兩個女兒良好的教育。我會繼續在國外工作,直到我的女兒們完成學業。第三件事,是2005年我贏得詩文比賽的第一名,這要歸功於我的父親。2003至2005年,我連續三年在詩文比賽獲獎。我熱愛寫詩及散文、從事藝術創作,以及插花。這些是上帝給予的才能,是上帝賜予我最棒的禮物。工作時,當寫詩的靈感湧現,我可能正在拖地。因此,我總是隨時準備好紙筆。

　　我在台灣參加了許多活動,從中學習、成長,在這裡累積了許多值得一輩子珍惜的回憶。攝影工作坊對於像我一樣的移工而言,是學習和經歷不同事物的良好機會,不僅具有教育意義,也兼具趣味及實用性。非常感謝你們!

<div align="right">翻譯:謝采秀</div>

Emy I. Derder

愛米・黛爾黛爾

I am Mrs. Emy Ilustrisimo Derder, 35 yrs old, married with 3 loving and beautiful children, I came from Cebu City Philippines, I worked here in Taiwan as a caretaker, a college level, taken up physical therapy, I am a kind, simple, honest, and hard working person. I take good care the old patient for 2 yrs. and 3 mos already. Watching the old patient is really hard for me, but I do my very best to tackle my job responsibility to understand the old patient situation. I gave him full support and patience, because he is just like my grandfather. With my desire, self discipline and determination in life, things are going all well.

I would like to say thanks to the TIWA for the opportunities you have given me; I learn more how to take a nice picture with caption. It wasn't easy for me at the beginning, but I tried my very best to do all my assignments even it may conflict with my job, because I am also a member of S.W.D.O.(samahang walang day off[1]). My employer allows me to go out, but every months just for a while. Before I decided to join the photo work shop, I already discussed with my employer and asked for the permission. Even though my schedule is so tight, I find the way to attend the classes, because I really love photography.

I had a good job in Philippines before I came to work in Taiwan. I came here to work because of my ambition to have a photography studio of my own. I used to work as a cashier and a studio photographer, taking portraits, making IDS, etc. Taking picture has been part of my life, I really enjoy it! I want to improve my skills, hopping that some day I can become a famous photographer. Then when it's time to go back home, I'd have knowledge of how to manage my money and to build a good business for the better life.

我是愛米・伊拉斯翠斯模黛爾黛爾太太，來自菲律賓的宿霧市，今年三十五歲，已婚並育有三個活潑可愛的孩子。我大專畢業，唸復健科，現在在台灣當看護。我個性和善，工作努力，單純直率。我替現在看顧的老先生工作，已經兩年零三個月了；照顧年邁的病人對我來說很有挑戰性，但我盡我最大的能力去了解老先生的需要，完成我的責任。我全力扶持他，對他更有耐心，覺得他就像我自己的祖父一樣。因為我對生命的熱忱、我的自律和意志力，一切都進展得頗順利。

我感謝TIWA給我這個機會，讓我學會如何拍出好的相片並放上文字說明成為動人的作品。雖然初步做起來並不容易，有時也和我的工作有所衝突，但我還是很努力地完成了每一次的作業。我同時也是無休假團隊[2]（S.W.D.O.）的成員之一。我的雇主允許我外出，但是每個月外出時間很短，我事先和雇主討論攝影班，以取得她的同意參加。雖然我的時間很少，但我還是想盡辦法參與每一堂課。

原本，我在菲律賓有一個很好的工作，但我希望到台灣工作可以多賺些錢成立一個照相館！我之前做出納，同時也在相館幫人拍照，我有拍肖像、證件照的經驗；拍照是我生活的一部分，我也非常地享受！因此，我希望自己的技術可以更精進，將來可以成為一位出色的攝影家。然後等我回家鄉時，我就有了管理資金、創業的知識，可以開創更美好的生活！

翻譯：王君琦

[1] "samahang walang day off" is how Philippine migrant workers make fun of themselves of being no days-off. There is no such an organization exists.

[2] samahang walang day off為菲勞社群中，沒有休假者的菲語自嘲的說法。並非真有這樣的組織。(TIWA註)

Evangeline L. Agustin

凡琪琳·阿庫思婷

My name is Evangeline L. Agustin. I was born on January 15,1968 in Banos, Laguna, but I grew up in father's place in Cardona, Rizal and finished my elementary and high school there. I studied my college in Tomas Claudio Memorial College in Morong, Rizal for my two years and move to Laguna to find a job. I worked at factory named Southern Dae Yeong Corporation for two years. A textile manufacturing owned by a Korean. While working I continue my studies at the same time at Laguna College of Business and Arts with the course of Bachelor of Science in Commerce major in management. Because of financial problem, I resign from the factory and drop all my subjects in school and apply in Singapore as a domestic helper and finished my two years contracts from 1989-1991. After returning to my homeland, I tried to apply back to the factory where I was working, but because of some reasons, my contract wasn't renewed and I become jobless again.

My husband is an electrician and was working in the factory also, but then the factory closed. That was the time that the situation pushed me to apply abroad again. I applied as a caretaker here in Taiwan year 2000, but instead of taking care an elderly, I worked in the piggery to take care of pigs. It's

ok for me because I also don't know how to take care of an old person. When the piggery closed, I went home. I applied back here year 2004 in Tianmu as a domestic helper until now. I have stay in Taiwan for almost 6 years already and very happy to work here.

Year 2003, I became a member of KASAPI(Kapulungan ng Samahang Pilipino)a Filipino migrant association here in Taipei. I participated in various activities and became an active member until now. I was very glad to take part and study photography in TIWA office which I know I can make use of what I have learned.

我的名字是凡琪琳‧阿庫思婷。我在1968年1月15日出生於拉庫納省的巴諾斯市，但我在父親居住的瑞克省的卡納多市長大，並在那裡完成中小學的課程。我曾在卡多納市的湯姆士紀念學院讀了兩年的大學，接著便搬到拉庫納找工作。我在一家名為南大元的工廠工作兩年，這是一家韓資紡織工廠。工作期間，我同時在拉庫納商業與技術學院修習學士課程，主修商業管理。由於財務問題，我從工廠辭職，並終止所有在大學裡的課業。我申請到新加坡當家庭幫傭，完成從1989到1991兩年的合約。回到我的國家之後，我試著申請原本工廠的工作，但由於某些因素，我的合約無法延續，而再度面臨失業。

我的丈夫是電工，也在工廠工作，但是後來工廠倒了。當時的情形迫使我再度申請到國外工作。2000年時，我申請到台灣成為看護，然而我實際的工作卻非照顧老人，而是在豬圈裡照顧豬隻。這對我來說還好，因為其實我也不太知道如何照顧老人。當豬圈關閉時，我也就失業並返回了菲律賓。2004年我再度申請到台灣工作，後來到了天母當家庭幫傭。直到現在，我在台灣已經待了將近六年，而我很高興在此工作。

2003年我成為菲律賓移工團結組織（KASAPI）的一員，這是在台北的一個菲律賓移民組織。我參與了各種活動，至今仍是活躍的成員。我很高興能夠參加台灣國際勞工協會所舉辦的移工攝影工作坊，我在這裡學攝影，並知道如何應用自己所學習到的知識。

翻譯：謝采秀、黃寶儀

Glorette Platon

葛羅瑞特·普藍登

My name is Glorette Platon, from Laguna Philippines, I am 38 years old. I have been working here for almost five years, and being far away home, I love taking pictures and send it to my family. Through pictures I wanted to express my feelings being migrants here in Taiwan. And most especially I like taking pictures as a keepsake. Since I joined this photo workshop I learned more about the importance and the meaning of photography.

Since then I am more carefully and think about the meaning of the pictures I have taken. Now I keep my pictures, because when I am growing old, I can see myself when I was young and my happy moments. That can not bring back and just for reminisce only.

　　我的名字是葛羅瑞特‧普藍登。我三十八歲，故鄉是菲律賓的拉庫納。我在這裡工作已經接近五年。遠離家鄉的我，喜歡照相片寄回去給家人看。透過照片，我想要表現身為一個在台外勞的感受。最重要的是，我喜歡藉此留念。自從加入這個攝影工作坊後，我學到更多攝影的重要性和意義。

　　自此之後，我拍照時更加小心翼翼，並且試著思考照片的涵義。我要保存這些照片，因為當我老去的時候，可以回顧年輕的我和這些美好時光。這些往事只待追憶，卻無法重來。

翻譯：Yen-ling Chen

Gracelyn Mosquera
葛雷絲林‧摩斯琪拉

I am Gracelyn Mosquera, 29 years of age. I came here in Taiwan last 2003 and working as a caretaker. Before I apply to work abroad, I was working away from my home town. There I found many good opportunities about artworks. Because of my love in the field of arts, I grab every opportunity. I have studied crochet making. Every weekends, I also study graphic designing, but I haven't practice it because I don't have my own computer. I also got myself into an artist group which I had my first exhibit in my whole life that made me very happy because I sold some of my paintings. And through this group I have done many charcoal paintings with a good pay.

Now that I'm here in Taiwan, I don't paint anymore because of having not much time and the nature of my work. But the second Sunday, from the time I arrived here, I become a member of Samahang Makata Int'l, a group of writers and poets and also joined the "Taipei Listen to Me" poetry writing contest after a year and won the second runner up. Now, another good opportunity came, this photography workshop. My father is a photographer for such a long time but I didn't dare to study how to use a professional camera. Now, I realize that I should. I was interested to join the workshop because I know I'm going to learn some-

thing that I could use in the future and every time I take a shot. So, every time I grab any opportunity, what is in my mind is that it is very useful to me, and it is!

　　我是葛雷絲林·摩絲琪拉，今年29歲。我於2003年來到台灣開始從事看護的工作。在出國工作前，我也是在外地工作。在那段工作的期間，我有許多機會和藝術接觸。基於對藝術領域的熱情，我把握每次參與藝術活動的機會。我學過毛線編織。每逢週末，我去上美工設計課程，但因為家中沒電腦，我並沒有機會練習。因緣際會下我也加入一個藝術團體，並舉辦了有生以來的第一次展覽。這次展覽的經驗讓我非常快樂，因為有欣賞者買走了我的作品。此外，透過這個團體，我創造了許多的素描，也有蠻好的收入。

　　在台灣，我不再畫畫了，因為我沒有那麼多的時間和靈感。但從我抵達台灣後第二個星期天開始，我參加菲律賓海外詩人作家協會（SMI），一年後我投稿「臺北，請再聽我說──第五屆外勞詩文比賽」並得到第二名。後來，又有另一個好機會出現，就是這個攝影工作坊。我父親是資深的攝影家，但我一直不敢學怎麼使用專業相機。現在，我了解該是時候了。我很喜歡這個工作坊，因為我明白在其中所學的將會在我以後拍照時派上用場。

　　所以，每逢我緊抓住機會拍照，我都會深深感到受益良多，因為的確是如此。

翻譯：育萍

Jun M. Sanchez

鍾・桑契思

Jun M. Sanchez is an overseas Filipino worker who came to work in a factory in Taiwan in 1996. Jun became active in cultural and community activities, and has also been volunteering in many Filipino affairs. In 1999, he established the Taiwan Chapter of Samahang Makata International, a Filipino Association of Poets and Writers.

Jun was born in 1964. He completed his primary and secondary education there and received a Bachelor's degree in the Science in Education from National Philippines University at Manila. In 1991, he completed a computer course in Microsoft Office (Professional) (first batch) at System Technology Institute (SMI) in Taiwan. Jun was also chosen as a Model Worker of the year 1999 at Foretech Electronics Corporation Limited.

As an artist, he was selected to be with SMI as Best Writer of the year 2001. His writings were published in the United States, Hong Kong, Singapore, Korea, Saudi Arabia, the Philippines, Japan, and Taiwan. He is the first aspiring Filipino writer that released his first book in Taiwan in December 2001.

The New Modern Heroes Award is an annual search for the outstanding Overseas Filipino Workers (OFW), initially launched by the Philippines' Overseas Em-

ployment Administration in 1984. The Awards are accorded to OFW workers whose courage, perseverance, and creativity epitomize the modern Filipinos as a paradigm of national skills and talents, and an Ambassador of goodwill. Jun is one of the recipients of the year 2003 award for outstanding services to the Filipinos abroad.

Every Sunday Jun buys a Taiwanese Newspaper. When he read in the news that there was going to be a photography workshop for immigrants organized by the Taiwan International Worker Association (TIWA), he called to register the workshop immediately, realizing that he might not be able to have a second chance to take part in such a workshop. He was very interested in learning more techniques and skills in taking good pictures. And the best is: he also thought someday he might be able to use the knowledge and skills he learned to open a photo studio and start a small business in the Philippines.

鍾・桑契思是一位在海外工作的菲律賓人，於1996年來到台灣做廠工。鍾非常熱衷參與藝文與社區活動，並且義務參與非常多與菲律賓有關的事務。1999年鍾成立了『菲律賓海外詩人作家協會』（SMI）的台灣分會。

鍾出生於1964年，來自菲律賓的東方金礦島（Oriental Mindoro）。他在家鄉完成小學和中學教育，並在首都馬尼拉的國立菲律賓大學取得科學的學士學位。1999年，鍾在台北的系統科技中心取得第一批微軟專業辦公室軟體課程受訓完成資格，並當選福業電子股份有限公司的模範勞工。

作為一位藝術家，鍾獲選2001年『菲律賓海外詩人作家協會』的最佳作家，他的作品已在美國、香港、新加坡、韓國、沙烏地阿拉伯、菲律賓、日本及台灣等地出版。2001年，他成為首位在台出版創作的菲籍作家。

『新英雄獎』是菲律賓海外工作部於1984年首創的年度獎項，旨在尋找和表揚傑出的菲律賓海外工人，表彰其勇氣、堅忍、與創意足以作為現代菲律賓人的象徵，以及作為民族技巧與才華的典範和親善大使。2003年鍾獲選為台灣的『新英雄獎』得獎人。

每週日鍾會買台灣的報紙來看，當他在新聞中讀到台灣國際勞工協會（TIWA）將舉辦一個移工攝影課時，他覺得機會難得，很快就報名了。他非常有興趣學習照相技術與技巧，更希望在未來能使用課程中學到的知識與技術開一家照相館，在菲律賓做一個小生意。

翻譯：王品

Lucile F. Alfaro

露西爾‧艾法蘿

How would my employer treat me? How would my life be with them? Fear? Fear of maltreatment, sexual harassment, starving, accusations, No! God will provide. I know he will take care of me,

I have been in Hong Kong for 11, 12 years and have had a great life living there. But my first year was really tough indeed. I slept on the floor in the living room, behind the dining table, a small tiny mattress, pillow and a thin blanket, all that made my first winter there so terrible. They even counted food in the refrigerator, especially eggs and bread. For the entire year, winter or summer, I washed clothes inside the bathtub; thin or thick, all hand wash. But slowly they changed, they saw how hard I worked, how I took care their sick mother, and they like the food I cook. They became kind and considerate. As my contract reached the end, it hurt when I had to leave.

My first six months in Taiwan was terribly hard, with 17 hours work a day. In Hong Kong I got a good salary (4500 HKD) plus a $410 HKO breakfast allowance and regular Sunday holidays, 2 statutory holidays. In here, almost nothing left after deductions of the broker's fee, health insurance, medical check up, etc. which makes me a victim of those illegal deduction schemes. Being accused

of stealing $100 NTD was like a slap in the face. Lucky, I have my journal with me. From my day one up to this day, I write down everything, including how much I spend everyday. I also keep all the receipts from the stores, re-mittances records and health insurance bill in my journal.

As they learned about how I keep my journal and see the way I work, take care of their kids, cook their food, they changed. They even brought me with them to their trips. As the Christmas gift, they allowed me to go back home to be with my kids and family on this very special occasion. It was the first and the only Christmas holiday that I ever had for my 12 years of working abroad. I would say God is so good.

我的雇主會怎麼對我？和他們一起的生活會是什麼樣子？我會恐懼嗎？會被虐待、性騷擾、挨餓、被指控嗎？不會的！上帝會給我我所需要的，我知道祂會關照我。

我在香港待了十一、二年，在那裡生活得很好。不過第一年很辛苦，我睡在客廳、飯桌後面的地板上，床墊、枕頭都很小，薄薄的毯子，冬天不堪其苦；他們對冰箱裡的食物，尤其是雞蛋和麵包錙銖必較；春夏秋冬無論衣物厚薄，我必須在浴缸裡用手洗衣物。但他們慢慢看到我工作認真、如何照顧他們生病的母親、做菜有一套，才改變了態度，他們開始對我很和善，也很體貼。當約滿要離開香港時，我也非常捨不得。

來到台灣的頭六個月，異常辛苦，每天工作十七個小時。在香港我的薪資很好（$4500港幣），不但每個禮拜天都有休假，每個月還有兩個週六也休假，還有約港幣410元的早餐津貼。但在台灣，扣掉仲介費、健保費、健康檢查費和居留證費用，根本所剩無幾。我就是那些仲介非法扣款的受害者。

被指控偷竊台幣100元的經驗，是我所遭遇到最大的一次打擊。所幸我每天寫日記，記下每一件發生的事、我的感想和每天的花用、保留所有店家的收據、匯款的收據和健保的收據。當他們知道我有寫日記的習慣後，更了解了我如何處事、如何照顧孩子及如何料理三餐，他們慢慢地對我改觀了，甚至還帶我和他們一起旅行。在聖誕節那個特別的日子，他們甚至讓我回家和我的孩子家人團聚，作為是送我的聖誕禮物。做了十二年的海外移工，　我從來沒有和家人一起過聖誕節。我要說，上帝真是如此恩慈阿！

翻譯：王君琦

Ma. Christina S. Antipala

克力斯緹娜・安緹帕拉

I am Ma.Christina Antipala from the beautiful country of the Philippines. Working here in Taiwan as a caretaker for almost 3 yrs. Toiling overseas to earn some money in return for my absence is really tough for my family especially my children who need my tender loving care w/c ironically. I provided my patient here. But its only for the meantime because this is not a lifetime job and its only our stepping stone for a better future. So while here I tried to use my spare time learning something w/c we can bring back home like this photography class. I love taking pictures but I have no idea what's the meaning these pictures want to tell the viewers, until I attended this class. I discovered that through photography we can express our feelings and emotion and the messages we want to deliver to our viewers. Our point of view w/c can be seen in our works through pictures viewed our sense of self. That's why it is true when we say that a picture worth a thousand words and I hope that through works you understand our feelings as a migrant and can sense the exact words that our pictures want to tell.

　　我叫克利斯緹娜‧安緹帕拉，來自一個美麗的國家──菲律賓。我在台灣做看護 工已快三年了。飄洋過海來工作的代價是我沒辦法陪在家人身旁，這樣的分離對我的家人和我來說非常的辛苦，尤其是對我的小孩，他們多麼需要我的照顧，但我卻在台灣照顧別人。不過這份工作是暫時的，我不會做一輩子，它是一塊墊腳石，通往一個美好的未來。所以在台灣的日子，我盡量用空閒的時間學習一些可以帶回菲律賓的東西，譬如說攝影。我愛照相，但在參加工作坊之前，我從不知道相片可以告訴觀眾什麼。我發現透過攝影，我們可以表達心情、感受和想要傳達給觀眾的訊息。透過作品，觀眾不僅能夠貼近我們的觀點，同時也看見了我們的生命。有句話說得很貼切：「一張照片勝過千萬字」。我希望透過這些作品，你能體會我們外來工作者的感受，也希望這些照片能說出我們想要說的話。

翻譯：Jennifer Lai

Ma. Belen A. Batabat
瑪實蓮‧巴塔巴

I was born on Jan 1, 1971 at San Juan Metro Manila, Philippines. I took Bachelor of Arts major in Psychology, but unfortunately, I wasn't able to finish it, due to some reason I couldn't be averted. I'm also a member of OFW family Club, Taiwan Chapter. Regards to my family, I have two brothers and three sisters. My siblings were all married and have children already. I don't have mother anymore, only father's alive.

Prior to my job here, I was engaged in selling for the family business——my family owned a small business of raising pigs. Due to not much money earned, we had to close it. So I tried looking for job opportunities in Taiwan.

I'm presently working as a caretaker at Taipei city. My ward is a cancer patient. He has a colon cancer. This job is not easy for me for I did not have the caretaking experience, especially for cancer patient. Beside, I also had misconception about cancer——of those who have cancers doesn't live longer then expected, and the pitiful look they might have——things like that.

When I accompanied my ward to the hospital for the first time, I was so nervous——imagine going to chemo therapy place everyday. But I must pretend that

I was okay.

The thing I'm also worry about is that my ward doesn't have any brothers or sisters in Taiwan, even his two sons are in Paraguay. In case anything serious happen, I have nobody to call except his friends from the church. Fortunately, everything turned out well.

Things have become easier for me, and I'm so thankful to the Lord. I've handled things well. And I know God has been good to them every time —— from the time of his surgery, where his faith had been tested —— his family really has that great faith in God, and I'm fortunate to share those things here.

我於1971年1月1日出生於菲律賓馬尼拉的聖左安區。我在大學主修心理學，但因為一些我無可避免的原因，無法完成學業。我是海外菲律賓家庭社團台灣支會的會員。關於我的家庭，我有兩個兄弟及三個姐妹，他們都已經結婚且有小孩，而我的母親已過世，只剩父親還在。

家裡養豬，我原本在家裡幫忙賣豬，但因為賺不到什麼錢，所以後來就沒再經營下去了。之後，我試著到台灣尋找工作機會。

現在，我在台北當家庭看護工，我的病人是癌症患者。他有結腸癌。這份工作對我來說並不容易──因為我之前並沒有照護的經驗，特別是癌症病患。除此之外，我對癌症可能也有錯誤的想法──我以為得到癌症的人總是活得比預料中的短、他們可能會有的愁雲滿佈的面容。我第一次陪我照顧的病患到醫院時，實在緊張得不得了──難以想像每天到醫院做化療的日子。但我必須假裝我還好。

另外一件我擔憂的事情是，我照顧的這個病人在台灣並沒有任何的兄弟姐妹，而他兩個兒子都在巴拉圭。所以，如果真有什麼嚴重的事情發生，除了他在教會裡的朋友，我不知道還可以打電話給誰。但目前一切事情都很順利。

事情對我來說變得簡單起來，我感謝上帝的恩典讓我能把事情處理好。我知道上帝也伴隨著他們──在他經歷每一次手術、每一次信念接受考驗的時候──他們的家庭真的對上帝都有很強的信心，我很幸運地可以在這裡分享這一切。

翻譯：黃寶儀

Maria Josefina Malinar Vaflor
瑪莉亞約瑟芬・馬莉納凡佛

This is my second term here in Taiwan.

I'm here to take-care of two old people, mainly, the man. He is not a bed ridden and can still walk using a walker. I just need to be there to assist him when he gets up to walk. The woman however, can still handle herself mostly. This woman has attitude. No one can change her, even her own son. She wants everyone to follow her rules, that makes no one likes to talk to her. And that is why she always tries to find excuses to complain about me, so that she can talk to her son. Other than that, she is also fond of saying bad words to me. Whether it is in the mid-night or during the day, she throws words whenever she sees me.

For me, I had no choice. It was the ninth month when I told Madam that I decided to quit and go home. Immediately, she called my Agency then told me to wait for the agent's call and to think twice. I didn't receive the agent's call, but realized that I was wrong. I apologized to Madam for what I've said. She accepted my apology and was pleased and let me stay. If it is not the debt that forced me to stay, I will not, because it's hard to deal with one's attitude like that. That is why I'm still here, waiting to finish my one year

extension.

Dear Lord,

I'm here with your approval, handling many problems in life. Help me to accept and face everything, especially to whom I'm taking care of. With your grace, I still remain. Save me from any danger and bring me home safe as I finish the contract. I endorse and trust with you all my personal and financial problems, including my life.

Maria Josefina Malinar Vaflor

這是我第二次來到台灣。

我在這裡照顧兩個老人,最主要的工作是照顧其中一位老伯伯。他並不是臥病在床,仍舊可以靠著助行器走路,我只是必須隨侍在側。如果他要站立,我必須扶著他站起來。老奶奶基本上可以自己維持生活機能,但她的態度很不好,沒有人可以改變她。她想要大家都聽她的,但沒人喜歡跟她說話,這也是為什麼她常藉故跟她兒子抱怨我。不只是這樣,她還喜歡對我講難聽的話,不論是白天,甚至在半夜,只要她一看到我,就會罵我。

對於我來說,我沒得選擇。工作到第九個月的時候,我告訴太太我決定要回家。她打電話給我的仲介公司,要我等候仲介回電並希望我重新考慮。我沒有等到仲介公司打電話過來,就了解自己做了個錯誤的決定,我為我所說過的話向雇主道歉。她很高興,讓我繼續留下來。

如果不是因為債務,我不會留下來,因為老奶奶的態度令人難以忍受。這也是為什麼我還在這裡,等著完成展延的最後一年契約。

親愛的上帝:

你容許我在這裡,處理生命中許多的難題。請幫助我接受並面對各種事情,尤其是面對那位我照顧的人。藉著您的恩典,我會堅強下去。請讓我避開危難、讓我完成這份合約、帶我平安回家。我將我個人及財務上的問題、以及我整個生命托付給您,我將全心全意信賴您。

翻譯:黃寶儀、謝采秀

Maricel Castelo Santiago

瑪莉・卡斯泰羅・聖地牙哥

I'm Maricel Castelo Santiago, presently residing in Neihu, Taipei City. I have a BS Bachelor's Degree in Accountancy, Computer Programming, and Midwifery (registered) graduate. Photography is one of my hobbies aside from writing poems and short articles. Recently one of my poems entitled "heart full of hope" has been qualified as a 3rd finalist in a poetry-writing contest——"Taipei listen to me."

Working abroad is not that easy because it's far away from home...from family. But knowing that I have employer who's kind, understanding, loving in their own special way, they understand all the thing I've done and my wrong moves and for that blessing I want to thank our God Almighty. I have been working here in Taiwan for almost 6 years and I enjoy it very much especially when God given the opportunity to meet those people from the following organizations: SMI (Samahang Makata International), KaSaPi (Kapulungan Ng Samahang Pilipino, the Group of Filipino Migrant Workers), MIGRANTE (Migrante Sectoral Party—Taiwan Chapter) and TIWA (Taiwan International Workers Association) family, since then I have been having the best time of my life. Joining this photography workshop is one of my happiest moments here in Taiwan. I am learning about styles of

taking picture and sharing my innermost dreams and feelings with others. As I love taking those fantastic views, I find place where my heart belong, and when I find this special place, peacefulness comes over my face. Tahu Park for me is the place where my heart belongs for it's closer to God and eternity.

I just want to thank the great people who had given me inspiration to release my hidden thoughts...TIWA family...from the bottom of my heart thank you all...

我叫瑪莉・卡斯泰羅・聖地牙哥，目前住在台北內湖。我有會計與電腦程式設計的學士學位，並且有合格助產士的資格。攝影是我在寫詩和散文之外的諸多興趣之一。最近我的一首詩『滿心希望』剛獲得『台北，請聽我說』詩文比賽的決選第三名。

赴海外工作其實並不容易，因為離家和家人很遙遠。但是真要感謝全能的上帝，讓我碰到了善體人意，關愛和包容的雇主，對我做的事或犯的錯都能諒解。我在台灣工作六年了，非常喜歡這裡，尤其感謝上帝賜予機會去認識菲律賓海外詩人作家協會（SMI）、菲律賓移工團結組織（KASAPI）、移工黨台灣支部（MIGRANTE）、和台灣國際勞工協會（TIWA）如家人般的朋友，自從認識這些團體之後，我的人生變成彩色了。參加攝影課是在台灣最快樂的時光之一，我學到了攝影的風格與訣竅，並且在過程中與學員分享我內心深處的夢想與感受。就像我喜歡天馬行空地去看世界，在鏡頭裡能找到我心靈歇息之處。當我找到這個心靈角落時，會感受到全然的平靜。大湖公園就是我的一處心靈角落，因為它更接近上帝與永恆。

我非常感激台灣國際勞工協會這個大家庭，啟發了我內在的想法與潛能，真心由衷地感激你們。

翻譯：王品

Maria Mechille Dacuno
瑪莉亞‧蜜雪兒‧達克諾

Allow me to introduce myself and share my thoughts on this photography workshop. My name is Maria Mechille Dacuno. I was born on May 14th in a small town of Samar, Philippines. I am single. I was raised up by extremely kind and loving parent. Although I grew up stony broke, poverty was not a hindrance for me to strive and pursue my learning and dreams. Fortunately, I obtained my degree in Education.

I have been working in Taipei City for over three year now with the same employer. Like most migrants, I am involved in household work. To be honest, I had a tough time of the beginning of my contract...I was homesick! It took a couple of months before I totally adapted myself to the new environment, new language, the people, the food, and so on. Being a newcomer in Taiwan who knew few words and phrase in Mandarin, that made me really difficult to communicate with the people in this community. However, I set my ultimate goal and eventually overcame these burdens.

I joined this workshop because I believe that being migrants we still deserve a chance to learn. And I was impressed that the "Taiwan International Workers' Association" (TIWA) in cooperation with "Kapulungan ng Samahang Pilipino" (KASAPI) strove to organize a wonderful atmosphere where migrant workers

like me were motivated, learned, and shared some photographic views of over-seas life. Through this workshop I had a perfect opportunity to share my inner thought, and a feeling of emptiness of living away from home. Aside from this I had given a golden chance to mingle with my fellow Filipinos as well as migrant from Indonesia. I am deeply grateful that I had shared this experience through photos.

I learned so much from this photography workshop. I am more interested and keen about the things around me than before. The ideas, information, and criticism of assignments that were given by enthusiastic instructors helped me a lot.

請容許我介紹自己並分享我參與攝影工作坊的心得。我的名字是瑪莉亞,生日5月14日,出生在菲律賓一個名叫沙馬的小鎮,目前還是單身。育我成人的父母極為慈祥,並且深愛著孩子。雖然自小家境不佳,貧困並未成為我追求教育與夢想的阻礙。我很幸運的獲得了教育學的大學文憑。

我在台北市工作了三年多,一直為同一個雇主服務。與多數移工相同,我也從事家務工作。坦白說,一開始的時光真是非常難受——因為我太想家了!過了兩三個月之久,我才真正開始適應這個嶄新的環境、陌生的語言、人群、食物等等。當時初到台灣的我,能夠運用的中文實在有限,這使我在跟左鄰右舍溝通時備感辛苦。不過,我為自己設定了努力目標,最後也終於克服了種種困難。

我之所以參與這個工作坊,是因為我深信,身為移工的我們仍應擁有學習的機會。台灣國際勞工協會(TIWA)與菲律賓移工團結組織(KASAPI)盡力營造了絕佳的氣氛,使得像我這樣的移工有機會在其中接受啟迪、學習並分享彼此從異鄉生活出發的攝影觀點;她們的努力讓我深受感動。透過這個工作坊,我得以分享自己的內在思考以及遠離故鄉的空虛感。除此之外,工作坊亦給了我機會與其他菲律賓甚至印尼勞工交際往來。我由衷地感謝能有機會以相片來分享自己的生命經驗。

我在這個攝影工作坊學到好多。充滿熱忱的講員所帶來的想法、資訊,以及她們對回家作業的指教,在在讓我獲益良多。

翻譯:曾涵生

Nida Quintay
妮達・奎答

God has given me, NIDA QUINTAY, as a gift to my parents on Aug 04. 1960. According to stories from my grand parents, I was born in one of the hospitals in Manila. My mother's name is Teresita Quintay, I don't know my father's name. My parents planned to get married at church after my father came back from his work in an international shipping company. However, that never came to reality because my mother died of heart attack a few days after she gave birth to me. My father was never informed about that because it was the time when communication wasn't as easy as now.

Despite the poverty, my grand parents reared me and my sister, brought us up with Christian values. They sent us to the catholic school in the LADY OF FATIMA SCHOOL. I studied there until finished high school. I was a work-study student when I worked on my college degree because my sister's high school teacher's salary was low. In prayer, we were able to go beyond the poverty, and I am now married with 3 children.

Life in the Phil. is so hard, I was forced to go work in Singapore so that my children will be able to go to college. After finished the term in Singapore,

I came home in the Phil and stayed for a while. As I think of the future of my children I applied the jobs in abroad again. Fortunately I was hired as a domestic helper in Taiwan. I stayed with my first employer for 9 years until completed my term. To my surprise and joy, the family of my employer all came to Phil to visit me. They stayed with my family and even sponsored the wedding of my first child.

Since it takes years before my children complete their college studies, I had to go back again to Taiwan. The employer I am working with now, is a nice family. I find joy in serving my employer as they respect me as their companion at home.

上帝在1960年8月4日給了我的雙親一份禮物一我,妮達・奎答。根據我祖父母跟其他親戚的說法,我是在馬尼拉的某家醫院出生的。我母親的名字是泰瑞斯答・昆泰。我不知道我父親的名字。當年我雙親計劃在我父親跑船回來之後就在教堂結婚,但這個計畫並沒有成真,因為我母親在生完我之後沒幾天就因心臟病發作過世了。我父親從沒被通知,因為當時通訊並不發達。

我的祖父母在艱困的環境下以天主教的價值觀把我養大,他們送我進天主教學校法蒂瑪聖母學院,我在那裡從小學念到高中。我是邊工作邊讀大學,因為我姐姐當高中老師的薪水是很低的。在天主的眷顧下,我們逐漸脫離貧窮的生活。我結了婚並有三個小孩。

因為在菲律賓的生活非常艱苦,所以我必須到新加坡去工作賺錢,讓我們的孩子將來能夠上大學。完成了在新加坡的合約,回到菲律賓的家並留在家裡一陣子。但想到孩子們的將來,我再度申請到海外工作。很幸運地,我找到了在台灣當家庭幫傭的工作。我為第一個僱主工作了九年,直到我的期限屆滿。出乎我意料之外的驚喜,我的僱主跟他的家人們到菲律賓來拜訪我,他們住在我家,甚至贊助我第一個孩子的婚禮。

離我的孩子們完成學業還要很多年,所以我必須回到台灣工作。現在我在一個很好的家庭工作。當我的僱主們尊重我、把我當成他們家庭的一份子時,我感到很開心能替他們工作。

翻譯:黃寶儀

Ronel D. Gonzales
羅納爾・鞏查斯

I'm Ronel D. Gonzales. I was born on September 22, 1976 at Palanan, Isabela, Philippines. In my family, I have eleven brothers and sisters and I'm the youngest among them. I'm a graduate of electrical engineering at Isabela State University in Ilagan Isabela in the year 2000. And I successfully passed my board examination for electrical engineer in the year 2001.

And I currently worked in Taiwan for four years and I'm working at Elegant Electrical Co. Ltd. As a factory worker, in our work we assemble motor control panels, remote control panel for robotic machines and we assemble water cooling cable for electric furnace. And we assemble a cylinder for mechanical.

And I joined a photography workshop sponsored by TIWA. And I learned how to take a picture in different angle or position and how to put a caption. I also learned how much the picture is powerful to use as an evidence. And I also learned how to make a criticism and differences into other places and different livings.

　　我是羅納爾・鞏查斯，1976年9月22日出生在菲律賓伊沙貝拉地區的帕娜亞市。我總共有十一名兄弟姊妹，而我是排行最小的。我2000年畢業於伊沙貝拉省立大學，獲得電子工程學位。隔年我順利地通過電子工程師的資格考試。我在台灣工作已有四年之久，服務單位是一家電子公司。作為工廠勞工，我們的工作是組裝自動機械裝置的馬達控制板、遠控模板，另外也要為電弧熔爐裝配水冷管。安裝機具裡的汽缸也是我們的工作。

　　我參加台灣國際勞工協會（TIWA）主辦的攝影工作坊，在裡面我學到了如何以不一樣的角度或位置來拍照片，並為照片添加說明。我也學到，當照片作為一種證據時，力量有多大。我還學到，如何以批判與另類的觀點，來看待生活的其他面向。

翻譯：曾涵生

逃

本文獲得第28屆中國時報文學獎報導文學首獎
原刊於2005年10月11日-12日中時人間副刊

顧玉玲

卡洛琳終於逃走了。

半夜三點，她從野雞車上打電話給我。

「我跑出來了。」她說，壓低聲音，像是要哭了。

「你身上有錢嗎？」我一直沒睡，心上惦記著她原訂早上九時返回馬尼拉的班機，惦記著她的淚眼汪汪和尚未還清的負債。

「我有三千元。行李都在旅行社，居留證、護照都在仲介那裡。」她說得急促，聲量還是壓抑著，想來是怕被旁座的人聽到，微微顫抖，緊張。

「朋友連絡好了？」

「嗯，你別擔心。」

「害怕嗎？」

「很怕。」

但我現在聽出來了，她的緊張裡藏著忍不住的興奮。噗通噗通，我彷彿聽到她的心跳聲，震耳欲聾；也可能是我的，在半夜，想像她在夜間飛馳的高速公路上，自由與危險，前途未卜。

停頓了二秒，她果真笑出來了，像總算鬆了一口氣。她說：「哦，我的天！你能夠相信嗎？我真的逃走了。」

錢沒還完，怎麼回家？

初入冬，逾百名菲律賓籍的女工把「台灣國際勞工協會」塞得滿滿的，熱氣騰騰。她們

多半年輕、活潑、問個不停，不時笑成一團，像在辦喜事；可話題一轉到近二個月沒領到薪水，有人流下眼淚，又哭成一團，路途險惡的他鄉異國。她們的文書能力強、行動快，前天才請她們整理所有外勞的來台日期、簽證到期日、護照號碼、平均薪資，今天就已經造冊、簽名妥當了。

「昨天早上到公司刷卡完，就要我們回宿舍等調班，每天都不敢出門，調來調去很累，可是又不算加班費，連薪水也不知道有沒有……」麥洛半夾雜著菲語、英語說。

「仲介要我們自動解約回家，不然就留職停薪，可是，我借了八萬元付仲介費，才來一年多，錢沒還完，怎麼回去？」個性豪爽的艾倫滿臉沮喪。

飛盟電子廠成立17年了，位於三重工業區的挑高辦公大樓，從事電腦主機板及介面卡加工、製造、及買賣，生產線全面自動化，廠房潔淨明亮，員工都穿著藍色的制服。一直以來，飛盟是台灣倍受稅賦優惠保護的高科技電子產業，不但被天下雜誌評選為「2000年台灣最快速成長企業第19名」，且接連拓展至大陸深圳、寧波、上海、北京設廠並註冊。可就資金匯流大陸的同時，台灣飛盟也快速萎縮、負債、資產被掏空，終至2004年10月起再也發不出薪水。

「工廠只是一時週轉不來。讓員工先辦留職停薪、回去休息，明年過完年要大家再回來，到時就是生產旺季了。」人事經理說話不急不徐，對於國際勞協的工作人員逕入工廠、宿舍，與本勞、外勞集結在早停工的廠房頂樓召開沒完沒了的討論，有明顯的不悅。

「本勞沒薪水，還有家裡勉強撐一陣子，外勞沒收入就沒飯吃了。」

「我們也很有誠意，上週開始一天發一百元給外勞吃飯呀。」人事經理在空調、隔音俱佳的辦公室，優雅地理了理深色西裝。

卡洛琳小聲說：「我們菲律賓人每天一定要吃乾飯。一百元根本不夠買三餐，宿舍又不能烹煮，我們幾乎都天天餓肚子！」

深入再追查，飛盟的廠房早已二次抵押，對外還有不少貨款未付，根本就只餘一個空殼子，繼續上市吸收游資，不肯宣布破產以迴避銀行討債。幾百個本地及外籍工人，還規規矩矩地打卡上工，被拖欠了整整三個月的薪資。

要行動，才會有改變

外勞宿舍平日門禁森嚴，早晚班後點名遲歸的人，罰款二千元，並處以下工後留守工廠無償打掃一個月，若打掃評量不及格，再罰二千元。她們一個月的薪資扣掉仲介費、稅金、勞健保費，大抵只有一萬出頭，食宿另計。麥洛攤開一大疊薪資單，作業裝錯接頭、辦理健檢、打卡遲到、電費超支分攤……零零總總的

扣款項目。

　　舊工廠改裝的女工宿舍，盡頭是洗衣間及成排的衛浴，有人在晾衣服，有人包著頭巾剛洗好澡。走廊的二側約有十餘個房間，門一概拿掉，女工們改以鮮艷的花布、垂飾、門簾替代，一眼望去，倒也讓水泥屋顯得溫暖明亮。幾個等待海運回菲律賓的大紙箱堆在走廊上，火紅的膠帶看來喜氣洋洋，還有人正忙著往半開的紙箱塞東西，毛絨絨的玩具、大包的土產零食、尚包著塑膠袋的成打T恤、亮晶晶的飾品……都是返鄉時必備的各式禮品。

　　走進房間，約六至十二個雙層鐵架床位不等，僅容半身高的床鋪裡間，幾乎都精心佈置過了，牆上的海報、相片標示著每個人不同的喜好及過往關係，床頭是鏡子飾品與日記本，床位前則各自懸掛著花樣色彩殊異的大毛巾或布簾，一垂放下來，才有了僅堪平躺、輾轉的個人隱私空間。

　　「公司再發不出薪水，我們也待不下去了。」楊說，她的眼神落寞：「我沒得選擇，只有先簽了留職停薪同意書，但我擔心一回去根本就沒機會再來。家裡真的很需要錢……」

　　一旁的萍亞，輕輕握住楊的手：「我們要爭爭看。如果台灣的法律這樣規定，我們就該拿回我們應有的。」

　　楊與萍亞是到飛盟才認識的。萍亞有個十歲的孩子在家鄉由母親照顧，單親媽媽的她遠渡來台工作，遇見楊，二個人穩定地發展一年多的親密情誼，共同規劃未來，也共同面對回菲律賓後可預見的阻力與壓力。外勞宿舍裡，姐妹們遠離家鄉的世俗牽絆，反而罕見地建立起十分友善而開放的環境，讓七八對同性小情侶在女生宿舍裡，自在愛戀、偕行。

　　「啊，她們是，不男不女啦。」當然也有人搖頭不解，可笑著私下説，沒形成逼人就範的普遍紀律。飛盟的女工宿舍，於是洋溢著友善的、不壓迫的、任她與她的性向自然流動、自由發展的集體氛圍。在抗爭時期，女同志們更多半出線主動扛起組織、帶動的幹部位置。楊與萍亞就扮演這樣的角色。

　　「反正，楊留下來，我留；她走，我也走。」萍亞聳聳肩，天經地義。

　　相較之下，才剛來台灣五個月的卡洛琳就顯得緊張多了，她今年三十六歲，未婚，蓄積了很大的勇氣才借貸來台，不料幾乎還沒領到薪水就進入抗爭。

　　有時候，卡洛琳會愁眉不展：「真的抗爭有用嗎？我很害怕，到現在還不敢告訴父母……」

　　有時候，她充滿勇氣：「上次談判後，仲介就把每個月強迫儲蓄三千元的帳戶先還給我們了。要行動，才會有改變。大家在一起的經驗，真是太棒了。」

整個冬天，大家的心情都起伏不定。每一次行動，女工們都要一大早塞爆了四、五輛公車才陸續從三重來到勞委會前，拿著前一夜寫好的中英文標牌、布條，自編了行動劇與口號，她們在勞動現場被壓抑的創造力、想像力與各式才華，卻在抗爭場上如此耀眼。

2004年歲末時分，本地勞工與外籍勞工的集體行動，總算逼使勞委會同意飛盟適用「大量解雇勞工保護法」，限制雇主出境。資方也終於承認停工事實，宣佈破產、歇業，本勞外勞得以申請勞保局發放工資墊償基金，補足三個月的欠薪，並向中信局的退休準備金請領資遣費。

爭了三個月，不過是恢復她們依法應有的權益。

她們是112個外勞配額

趕在舊曆年前，飛盟外勞終於要轉換雇主了。

三重就業服務站特地借了市公所的大禮堂來進行轉換作業，電子媒體也聞風而來。會場上，仲介幾十人坐一邊，112名飛盟外勞坐一邊。我們設想中，買方賣方互看資料、互相挑選、互相比較的面試過程，完全沒有發生！或者說，資訊只默默地提供給買方，幾十個仲介手上一疊女工的基本資料，姓名、年資、年紀等，一應俱全。外勞則什麼都沒有，沒有翻譯，沒有說明，沒有任何可參考的書面或口語素材，像市場上的豬肉，待價而沽。

「好緊張哦！」卡洛琳特地上了口紅，頭髮梳得齊整：「如果沒有人要我，怎麼辦？」

幾對小情侶都坐在一起，用力握著手，彷彿要讓買方一時眼花，把兩位一體帶了回去。我繞到官員背後細讀中文公告的廠商記錄，哇！出乎意料，登記申請承接的廠商從南到北，竟高達一百七十家！但每個工廠預計可承接的名額卻只有一名、二名、至多六名。唉，拆得這麼散，大家可真得各奔西東了。

「我想待在北部，可以嗎？」

「我不挑地點，只要我們在一起就好，可以嗎？」

「還是在電子廠嗎？我的肺不好，不可以是紡織廠……」

……沒有人能夠回答。可以問嗎？可以要求嗎？可以同意或不同意嗎？

「麻煩你請一名外勞代表上台來。」就服站謝專員客氣地說。

「做什麼？」

「代替大家來抽籤。」她和善地、示好地表示：「今天外勞很多，我們讓外勞來決定那些廠商可以得標。」

「啊?」

外勞來抽籤?中籤的廠商可以讓外勞優先挑選嗎?結果當然不是。

抽籤,真的只是抽籤。在台灣,許多廠商的資產額及產業別未能符合引進外勞的資格,勞委會的新政策卻不設限地開放這些小廠商得以「承接中途轉換雇主的外勞」,承接一名外勞就擁有一個配額,一個廉價勞動力的使用權。於是,飛盟宣佈關廠解約後,112名外勞配額就憑空掉到這個買方大排長龍的市場上。

排隊等抽籤的工廠名稱全被寫在籤條上,放在空罐子裡,由外勞代表一張張抽起。抽到哪家廠商,仲介就唸出已圈選好的外勞代號,例如:「24號、25號」,我緊鄰著仲介區坐,看見所有仲介都快速地把名單上的24與25號畫掉,沒有想像中「幹!怎麼我看中的人被先選走了!」的遺憾與惋惜,基本上,圈選的人甚至也沒有多看外勞區的眾多臉孔一眼(啊,卡洛琳的口紅根本派不上用場!),而是直接順著還沒被選上的號碼依所需名額依次往下勾(唉呀,我們本來還怕幾個契約快到期的會沒人選呢!)……總算明白了,這個承接的遊戲規則裡,買家只關心「還剩多少名額」,一個仲介手上可能有數家至數十家委託廠商的籤條,他們經驗老道地耐心等待,不四處張望,面無表情。

同時間,隔著一條走道的外勞區。所有的人聚精會神,緊張、擔心、興奮、互相打氣。

每一個號碼被喊出口,都引起同等激烈的騷動,選到我了!幾乎所有人都沒有例外地大喊出聲,四週的人也立即不知是喜是憂地響起迴音。等回過神來,個別的人開始有尖叫外的反應了:「啊!我們有四個人!」跳起來擁抱大叫、熱情奔放。也有人故作輕鬆:「一個人也行,希望遇到不關廠的老板。」一一握住所有伸過來安慰的手。還有小情侶的眼淚應聲而落,被拆散的兩人哭紅了眼。

號碼被勾選了,但是,究竟要去那裡啊?什麼樣的工廠啊?沒有人知道。她們偷眼打量著喊出自己號碼的人,那時還不知道全是仲介,有人悄聲說:「還好,這個老板看起來不太凶。」無效地找點足以判斷、評估的蛛絲馬跡,好聊以自我安慰還算進入一個正常的「就業面試」的想像狀態。

她們是112個配額,籤抽完了,轉換作業立即宣佈結束。個別仲介火速清點外勞人數、核對護照,催促上車:「快點,行李都整理好了吧?一到宿舍,就趕快把行李搬下來,我們開車回彰化,還有四個小時!」、「走了走了,到高雄都天黑了!」、「光土城就有四家工廠,一家家送,還要跟老板說明一下,時間來不及了。我幫你們叫好便當,就在車上吃一吃好了。」……一個個陌生的地名,通向未卜的前程。

「好期待新工作哦!我從來沒去過台北以外的地方欸。」卡洛琳的行李不少,但她的情

緒高亢。她們一伙十人全上了同一個仲介的小巴士，工廠都在台中、彰化一帶，她和維琪同一個廠，有人作伴，信心大增。

「工作穩定了，一定回台北看你們。」卡洛琳搖下車窗，很用力的揮手。

我鬆了口氣：「太好了，工作全有著落。我們本來很擔心幾個超過三十歲的、居留證快到期的，會沒人要呢！」

身旁一名沒抽到名額的仲介，輕輕地搖了搖頭。「依我的經驗，這些外勞大概有百分之三十，一個月內就會自動解約回家了。」他老道地說。

這個警訊，很快就應驗了。

不能做，就要遣返

送走最後一批人，我們精疲力盡的坐上回國際勞協的車子，半路上，手機就響了。

「這個地方，我們根本不能工作！」是穩重的楊，她的聲音裡全是驚惶：「我們在林口，電焊、鍋爐、打鐵，沒有一個女工！怎麼辦？」

之後二天，國際勞協所有工作人員的手機就再也沒有斷線過。

「仲介說，我不做就要把我遣返！」

「根本沒有女生宿舍，他們要我住在男生宿舍裡，連洗澡都一起！」

「我的行李都還沒放下，老板就說不要女工，為什麼聘我們來？再把我們解僱遣送？」

「仲介已經訂好機票了，今天半夜就要來接我去機場！」

移民身份，最大的威脅就是處在「隨時可以被遣返」的壓力下，只要人一離境，一切明文規定的權利都無從追討。語言的劣勢、資源的欠缺、政策的自相矛盾，在在使得她們動彈不得。

楊被送到林口的鍋爐廠、卡洛琳到了鹿港的五金廠、還有人在水泥拌鑄廠、鋼鐵廠、鐵沙廠、大型傢俱廠。112名女工離開自動化的電子廠，約有三十幾人無預警掉入重機械小型工廠。無法進入粗重工作的女工，次日凌晨就被仲介強押至機場遣返，好空出沒有外勞的「外勞配額」以讓雇主重新申請男性外勞。

2003年9月通過公布的「外國人轉換雇主或工作程序準則」，第九條中明訂轉換雇主時，應以「公開協調會議」方式，辦理外勞轉出；同法第十條中規定，轉換「應依外國人原從事行業之同一工作類別」。但事實上，外勞雖然人到了現場，卻完全在封閉的資訊下，沒有選擇與拒絕的權利，更別說是協調了。而同工作類別，也幾乎是所有申請廠商照單全收，從麵包廠、碾米廠、到鐵工廠都有。在這個「搶

人頭」的買方市場，不管性別、國籍、適用與否，只要搶到手了，不好用立即遣返，雇主就多了一個重新申請的外勞配額，仲介也多了一個與海外仲介公司抽成引進的賺錢機會，而不分青紅皂白被搶走又送走的外籍勞工只有一身負債地回到母國。

一週內，從南到北，果然幾近百分之三十的飛盟外勞，陸續回到三重原宿舍等待協商。有的人，護照、行李都還扣在仲介手上；有的人，機警地以手機拍下勞動現場的相片。沒料到，才為薪資抗爭完，竟又要再為工作權抗爭，而這次對象是不當的外勞政策。女工們指證歷歷、憤怒落淚的外勞影像上了報，勞委會不得不公開承認轉換過程有瑕疵，不得不同意一一調查個案，再協調「二度轉換」的可能。

國際勞協耗費所有力氣一一與雇主溝通、遊說，總算讓數十名女工在政策夾縫中破天荒取得二度轉換雇主的機會，經歷了台灣首度稍有文明、有翻譯、有說明、依法行政的外勞轉換作業。楊與萍亞總算如願以償，相約一起轉換到彰化的零件廠，每天工作十二個小時，互相扶持，等半年後約滿返家。

卡洛琳的老板原本很客氣：「我們也是第一次承接外勞。本來想聘個男工，不知道怎麼會排隊等到一個女的。既然勞委會說可以再轉換，當然沒問題！她們外勞也是很可憐啦。」

偏偏勞委會的政策一攤開：「外勞配額轉出，雇主重新排隊」，老板立即改口，信誓旦旦向官員承諾會安排適任工作給卡洛琳，如何也不肯放她走。

「辛辛苦苦輪了好久才抽到外勞配額，讓她走，我們的損失誰來照顧？你們為什麼要幫助外國人呢？我們都是台灣人……」很多老板這樣說。

關鍵在配額。勞委會設了一套勞資互相牽制的政策，為配額只能你死我活，逼得承接雇主與外勞的利益衝突，逼得勞資無法共處，逼得沒條件的人只能鬆手、再無退路，粉身碎骨。

卡洛琳的眼淚直流：「真的，女職員都是坐辦公室的，在現場工作的，只有男工。我不是懶惰的人，在菲律賓，我也在工廠工作，也很辛苦，但這個工作我真的沒辦法做，我和維琪試了幾天，腳都腫起來了。真的，我想賺錢，不是不能做我不會堅持的……」

雇主不放人，被迫又要回到原廠「安排適任工作」的外勞們，包括維琪，都立刻作了決定：「不必再試了！再做下去只會逼我們自己解約回家。夠了！我再也不想待在台灣。」

唯獨卡洛琳不肯。她睡不著，眉頭深深陷落二道刻痕：「我連從馬尼拉機場到家裡的車錢都沒有。至少要等到飛盟的積欠工資發下來，我不能現在離開！」

這些離鄉背井外出打工的女人，都有一身

的勇氣與能耐，得以應付最難堪的對待，與最窘困的處境，可她們的移民身份這樣脆弱、不堪一擊，除了認賭服輸，就只能奮力忍耐。留與走都是豪賭，而卡洛琳的籌碼這樣少：「唉，這個決定是對的嗎？有別的路嗎？」

最終，只有卡洛琳扛著行李，一個人回到她才剛逃離的工廠。

再查，再查也是一樣

過年期間，斷續收到卡洛琳的簡訊：「我的工作還好，清洗機器、掃地，很忙，但沒讓我做我做不到的事，我會忍耐。」我暗自祈禱：「至少，捱到還完仲介費吧。」工人的命運幾乎都是這樣，想翻身是絕不可能了，只能拼命找出路，在結構性的困局中，少輸為贏。

但相安無事的日子不到二個月，掃地的好時光過完了，卡洛琳開始被要求上線做粗重的搬運與鑄造工作。

春節剛結束，她打電話來，一開口就是哭：「怎麼辦？老板要逼我做很難的工作了。我說我不行，領班就一直罵我，說不能做就回菲律賓呀。」

「卡洛琳，別哭了！我們早知道會這樣不是嗎？打電話給勞工局要他們到現場調查。」

「領班一直罵我笨，我聽不懂他在說什麼，但他很凶……」

「所以？」

「我生氣了，我對他們說：走就走！我不幹了！」

我心中一緊。糟了！外勞在台灣是沒有轉換雇主的權利的。除非是受照顧者過世、原雇主放棄聘用、或關廠，基本上不論工作條件如何惡劣，外勞是無法如一般本地受雇者以辭職篩選壞老板的。外籍勞動力商品的特殊性，在於限業限量限期引進，一律採最低薪資。再如何糟糕的勞動環境，只要不是明顯違法，外勞若要辭職，只有遣返一途，再沒其他出路。這下可好了，工廠原本就想找個男工，現在總算逼得卡洛琳自己說出解約，看來遣返的動作會很快了。

「我知道我說錯話了，可是我真的很生氣，他們一再欺騙我，而且在那麼多同事面前大聲罵我，好像我是個傻瓜，沒有自尊心。」她說著說著，反倒沈著下來，她知道她沒犯錯，卻要承擔惡果。

當天夜裡，卡洛琳就被送到機場了。抗爭磨練來的經驗與膽識，卡洛琳不哭了，她進了海關，等仲介離開後，撕掉登機證，逕自找了航警，冷靜地連絡勞委會，要求官方履行過年前承諾的勞動調查，並住進庇護中心等待勞資協商。

台灣官方找來菲律賓在台辦事處的官員，雙方都勸卡洛琳息事寧人，離職書都簽了，就

回家吧。

「菲辦就怕麻煩，一出事，只想快把我們趕回去。他們都不想一想，幾百萬的菲律賓海外工作者，每年幫我們的國家賺多少外匯，填補政府財經政策出問題的漏洞？所有的官方都不可信任！」卡洛琳幾乎是不屑的。

「這個案子過年前不是調查過了嗎？怎麼又要再來一次？」地方勞工局也不耐煩了。

「年前說要調任她能負荷的工作位置，年後就換了樣。是你們要卡洛琳先去做，出問題再協商。」

「有的外勞真的很壞，你不要只是聽她單方面說辭，我們台灣的老板和仲介要不要生存？再查，再查也是一樣！」仲介說。

果然還是一樣。調查、協商結果是卡洛琳解約返國，沒別的選擇。一群工人還有集體抗爭、改變政策的可能，一個人又如何形成壓力呢？卡洛琳第三度被送到旅行社，等待一早的班機飛回馬尼拉。當天半夜，她什麼證件、行李也沒帶，一個人走出旅行社，直奔車站。

在北上的夜間巴士途中，她打了最後一次電話給我。

鬆動一點活路

根據勞委會統計，截至2005年5月份止，共有1萬7959名外勞逃跑，其中男性4731人、女性1萬3228人。上個月警方共查獲538名逃跑外勞並遣送出境，其中男性167人、女性371人……。

卡洛琳會是這連串統計數據中的那一個呢？逃走，由於無法自由轉換雇主，唯有從這個天羅地網中逃走，才能鬆動一點活路。而逃跑，也使她從「拿不到薪水的關廠受害者」，一夕間成為「勞委會與警察局全面通緝的非法外勞」，她從一個汲汲可危的強制遣返處境，被迫藏身到更不安全的非法身份。

我還是會斷斷續續收到卡洛琳的簡訊。她在台灣的某個角落勞動、生存下來，看見警察就害怕，不容易在新的勞資關係中議價，陷入更底層的勞動。飛盟積欠的三個月薪資總算由勞保局代墊發放給所有的本勞外勞了，但外勞部份都被先扣了百分之二十的高額稅款，卡洛琳及其他被迫返鄉的外勞們，都沒機會出面為自己辦理退稅了。我只但願她平安健康，畢竟沒有健保、勞保護身，在台灣是沒條件生病或意外的。

我想著她在他鄉異國艱辛地求生存，一如我認識的許多移民勞工，他們來來去去，從低度發展的國家移動到貨幣價值較高的國家，賺取當地最低廉的工資，學習以有限的資源生存下來，想盡辦法還債、存錢，為個人或一整個家庭尋求更好的出路。這個夢想，不一定會實現，且多半陷入更慘烈的處境。

有時候我會擔憂。當國際勞協又接到逃跑外勞為躲警察而從高樓摔死的案子，我心中不免想到卡洛琳。若真被警方發現了，就束手就擒吧，別反抗了，不要付出更大的代價。真的，弱勢者只能少輸為贏。

有時候我會放心。想著她好不容易免去仲介巧立名目的高額抽成，好不容易可以自主找工作、換老板，也許真開始存錢、還債了也不一定。卡洛琳一向很會打理匯兌事宜，總能找管道挑選穩靠的地下金融。

卡洛琳奔逃的剪影不時出現在我眼前。我彷彿看見她飛快奔跑時，疾揚的長髮，移動的身形，在初春的夜半街道上，踉蹌前進。再前進。

台灣國際勞工協會秘書長

得獎感言：

知道得獎的消息時，我們正為了821高雄捷運的泰勞南北奔波。一千七百多名忍無可忍的卡洛琳，終於以集體的抗暴行動震驚全台，SNG車開進外勞宿舍，把窘迫的、堪稱奴役的勞動條件送到大家眼前。而這已經是台灣立法引進外勞第十四年了！

我有幸，長期貼近基層勞動者在有限的條件下奮力搏鬥、挫敗擠壓、長出／或沒能長出力量的歷程。我有幸，共同參與衝撞體制的抗爭，並撕裂般地被滋養與改變。如果我大量使用「我們」作為敘述的主詞，那確實是因為行動的背後是組織性的支持力量，而一起熬夜打拼的素香、靜如、燕堂、醒之、競中…也是作者欄中必須被併列的名字。

記錄弱勢者用力發聲的歷史，是集體實踐的一部份。而得獎無疑會有加倍擴音的效果，獎金對勞協房租的挹注也著實令人高興。真的很高興。

台灣移工圖像

龔尤倩

　　六○、七○年代勞動力密集產業創造了台灣經濟的奇蹟，隨著經濟發展，土地工資成本的上揚，台灣產業再也無法依恃島內自農村釋放廉價勞動力的優勢。產業外移出走成為趨勢，引進移工成為政府要求企業根留台灣的策略之一。1989年，行政院以「十四項重要工程人力需求措施因應方案」引進了泰國籍勞工，1992年就業服務法通過，則正式確定了台灣的移工政策。

　　於是，捷運、高鐵、醫院與社區公園……，一一看到了這群移工與我們共生共存的身影。截至2007年2月，台灣有341,623名藍領外籍移工，佔全部人口的百分之一‧四，佔總勞動人口的百分之三。半數藍領移工從事製造業，另一大宗則為外籍監護工佔了百分之四十四，泰國印尼菲律賓以及越南籍人數分別為七萬至九萬不等，馬來西亞以及蒙古則低於百名。

移工所面臨的處境

　　1992年頒布的就業服務法中，對藍領移工以及白領移工進行了區隔規範。專業白領外國人[1]的聘雇，採取的是個別許可制，工作許可的取得沒有配額的管制、契約及工作居留的年限也無上限。而移工的雇用，採取的是所謂「客工」（Guest worker）的模式，雇主的聘僱資格受到配額的管制，移工只允許在契約期間擁有最長六年的工作居留。和自由流動的白領專業移工不同，低階移工被剝奪了在勞動市場流動的權利，他們只能為一個特定的雇主工作，除了少數例外條件，不得轉換雇主。

1根據第46條，包括專門性或技術性之工作、華僑或外國人經政府核准投資或設立事業之主管、外僑學校及外國語文教師、運動教練及運動員、宗教、藝術及演藝工作。

台灣外籍移工人數 2007年2月							
產業別 ＼ 國籍別		泰國	印尼	菲律賓	越南	馬來西亞	蒙古
總數	341,623	91,832 (26.9%)	91,294 (26.7%)	88,715 (26%)	69,738 (20.4%)	11 (0.0%)	33 (0%)
製造業	169,167 (50%)	79,871	8,223	58,067	22,976	11	19
營造業	11,728 (3.4%)	9,649	44	1,305	730	-	-
漁工	3,417 (1%)	14	1,902	813	688	-	-
監護工	157,311 (46%)	2,298	81,125	28,530	45,344	-	14

資料來源：行政院勞工委員會、行政院內政部

　　台灣政府提出其外勞政策四大原則：「外勞必須是補充性勞動力、防範外勞成為變相移民、避免製造社會與健康問題、不得妨礙產業升級」。在這四大原則之下，九〇年代以來的台灣移工管理制度有以下的特徵：

1. 政府控制引進移工之產業與人數。

2. 限制移工在台灣的工作期限。為了要避免造成移民現象，移工在台灣依其工作簽證居留，三年期限一到移工必須出國一天，俟後可在台灣繼續另三年之工作。當他們完成了在台灣的工作期限，移工必須離開台灣並且不得再以移工身份回到台灣工作。

3. 移工必須有良民證並通過例行健康檢查。移工入境前後以及每隔一年必須經台灣政府認證的醫療院所進行健康檢查。一旦健康檢查不合格，移工將無法取得聘僱許可，面臨出境的命運。移工於取得簽證前必須備有母國當地之良民證，以作為審核其行為的標準。

4. 限制外籍勞工的移動。移工的居留處為雇主地址，不得任意移動，只有在關廠，照顧對象往生，性侵害與騷擾等特別嚴重情況下始得轉換雇主。

5. 配額管制循環使用的設計。一但雇主所雇用的移工行蹤不明將喪失配額，這樣的設計造成雇主嚴格控制移工，於是雇主透過扣押護照，居留證或者是所謂的強迫儲蓄[2]，限制移工的假日行動以避免移工的逃跑，這些種種措施往往違反移工人權。

6. 私人仲介的引進。引進移工的程序複雜繁瑣，加以配額制度以及仲介市場的競爭壓力，仲介公司搶單所造成的惡性競爭，仲介將相關支出費用轉嫁到移工身上，高額仲介費造成的問題，是台灣移工面對的最明顯直接的剝削。據2002年台灣官方統計，移工必須要付出新台幣十一萬元至十五萬元作為仲介費用才能來到台灣。

7. 不准家庭團聚。來台工作的藍領移工不准在台結婚、攜眷，更沒有家庭團聚的權利；其合法居留期間也被排除在歸化申請資格之外。

8. 外籍家務勞動者填補社會福利漏洞。2007年2月外籍家務勞動者佔了總外籍藍領工人之百分之四十六，約十五萬人。台灣殘缺的社會福利制度以及老年化的社會現象，造成了近年這些外籍家務勞動者的數量不斷上揚。根據勞委會統計，外籍看護工平均工時高達每日12.5小時，她們以以長工時、低工資的勞動條件，持續修補著台灣照護制度的缺漏。勞委會曾於1998年4月將家事服務業勞工納入勞基法適用，但於1999年1月又取消適用。由於家庭類勞工被排除在勞動基準法的適用範圍外，使得這塊殘缺的公共社福領域徹底私人市場化，欠缺工時、休假、工作內容與勞動條件的基本保障；台灣國際勞工協會與天主教移工團體並組成「家事服務法聯盟」，倡議制定家事服務法以保障家務勞動者的法定權益。

台灣的外籍藍領勞工被政策定位在不能久居的「客工」，低階移工只是台灣勞動力的補充，社會的過客。在這樣的設計之下，相關藍領移工的控制結構，諸如，在勞動市場上限制六年的工作年限，無法自由轉換雇主，無法自組工會，而私人仲介制度更加深了移工面對的債務的控制，更使得移工面對控制的結構噤聲，2005年的高雄捷運泰勞抗暴事件，正徹底突

2 台灣政府曾經在外國人聘僱及管理辦法中，明定雇主得以每月從移工薪資中扣30%作為儲蓄款，待移工契約期滿再行返還，移工團體稱此一違法措施為「強迫儲蓄」 或是「防止逃跑保證金」。

顯了台灣的移工政策已成了「新奴工制度」。這樣的制度與長期家務勞動者無法律保障的處境，也使得台灣被列名為美國國務院2006年人口販運的觀察名單。

國際天主教嘉祿移民組織台灣分會執行長／台灣國際勞工協會顧問

Portraits of Migrant Workers in Taiwan

Yu-Chien Lorna Kung

In the 1960s and 1970s, labor intensive industries created the "economic miracle" in Taiwan. Along with the economic developments, the costs of land and labor soared. Taiwanese industries could no longer rely on taking advantage of cheap labor from rural areas. Transferring industry abroad became a trend, and the importation of migrant workers became one of the strategies the government used to urge the industries to "stay rooted in Taiwan." In 1989, the Administrative Yuan began to import Thai workers according to the Measures in Response to the Demand for Manpower in Fourteen Major Construction Projects. The adoption of the Employment Service Act in 1992 affirmed Taiwan's migrant worker policy.

The Population of Foreign Migrant Workers in Taiwan (2007 February)							
Industry \ Nationality		Thailand	Indonesia	Philippine	Vietnam	Malaysia	Mongolia
Total	341,623	91,832 (26.9%)	91,294 (26.7%)	88,715 (26%)	69,738 (20.4%)	11 (0.0%)	33 (0%)
Manufacture	169,167 (50%)	79,871	8,223	58,067	22,976	11	19
Construction	11,728 (3.4%)	9,649	44	1,305	730	-	-
Fishery	3,417 (1%)	14	1,902	813	688	-	-
Care Takers	157,311 (46%)	2,298	81,125	28,530	45,344	-	14
Sources: Council of Labor Affairs, Executive Yuan and Ministry of the Interior							

Therefore, no matter whether it is the Taipei Metro, High Speed Rail, hospitals, or community parks, we see migrant workers living and working with us. As of February, 2007, there are 341,623 blue-collar foreign migrant workers in Taiwan, which amounts to 1.4% of the total population or 3% of the total working population. About half of the blue-collar migrant workers are in the manufacturing industries, while 44% are care takers. The amounts of workers from Thailand, Indonesia, Philippine, and Vietnam range from 70,000 to 90,000, while those from Malaysia and Mongolia are less than a hundred.

The Plights of Migrant Workers

The Employment Service Act of 1992 differentiates blue-collar migrant workers from white-collar ones. The employment of professional white-collar[1] foreigners is regulated by the system of individual permissions. There is no quota for the number of work permits issued each year, nor limit on the years of contracts or the duration of stay. Migrant workers, however, are regulated by the so-called "guest worker" system: the employment is controlled by quota, and migrant blue-collar workers are only allowed to stay during the contract period and for six years at most. The low-level migrant workers are deprived of the rights that white-collars have. Migrant workers can only work for their designated employers. They are not allowed to change employers, except in some extraordinary conditions.

Taiwan's government announced four basic principles for its migrant worker policy: a) To ensure that migrant labor is only a supplementary labor force; b) To prevent migrant workers from becoming de facto immigrants or long-term residents; c) To prevent migrant workers from creating social and public health problems; d) Not to interfere with or retard industrial development. Guided by these four principles, Taiwan's administration system of migrant workers has the following characteristics:

1. The government controls which industries may import migrant workers and how

many workers may be imported.

2. Migrant workers are allowed to work in Taiwan only for a limited period. After a maximum stay of three years, migrant workers must leave Taiwan for a minimum of one day, so that they are not eligible to apply for permanent residence. After finishing their stay, migrant workers must leave Taiwan and cannot return as migrant workers again.

3. Migrant workers must submit police clearances and pass routine health checks. Before and after coming to Taiwan and every two years thereafter, migrant workers have to submit health clearances issued by the hospitals approved by Taiwan's Department of Health. If the health checks fail, they cannot renew their work permits and will be deported. Before obtaining their work visas, migrant workers have to prepare police clearances from their mother countries as verification of their standard of behavior.

4. Migrant workers have only limited mobility. Migrant workers have to reside with their employers. Migrant workers are allowed to change employers only when the factories are closed, the patients whom they are hired to take care of pass away, or in cases of serious maltreatment such as sexual abuse or harassment.

5. The quota system is controlled by "cyclical reuse". According to the current legislation, an employer will lose his or her quota if the hired migrant worker runs away. This kind of legal system leads the employers to strictly control the migrant

[1] According to Article 46, professional white-collar foreign workers are in one of the following job categories: those requiring special and technical skills, managerial positions at business enterprises with overseas Chinese or other foreign investments, teachers at educational institutes for foreign residents, language teachers, coaches, athletes, and work related to religion, art, and show business.

[2] Almost all employers deduct a part of the workers' salary (NT 3,000 or US$90) every month, till the time the workers finish the contract and return home; the deducted money is returned to them on their departure day.

workers by confiscating their passports, by "forced saving plans," or by restricting migrant workers' social activities during their vacation.[2] These strategies adopted by the employers often violate the human rights of migrant workers.

6. Migrant workers are recruited by private agents. The complicated process to import migrant workers, the quota system, and the pressure of the competition between brokers lead the brokers to transfer their costs to migrant workers. The high broker fee is the most obvious and direct exploitation of migrant workers in Taiwan. According to statistics provided by the Taiwanese government, a migrant worker has to pay between NT$110,000 and $150,000 as the broker fee before she or he can come to Taiwan.

7. Migrant workers are not allowed family reunions. Foreign blue-collars are not allowed to marry in Taiwan or to bring their families. The period of their legal stay does not qualify them to apply for naturalization.

8. Foreign domestic workers are used to cover up the loopholes in Taiwan's social service net. By February 2007, one hundred and fifty thousand foreign domestic workers constituted forty-six percent of all foreign blue-collar workers in Taiwan. That Taiwan's welfare system has not been well designed for this ageing society results in the continuous increase of the number of foreign domestic workers. According to statistics from the Council of Labor Affairs, the average working hours of foreign caretakers are as high as 12.5 hours/day. The long working hours and low wages of foreign domestic workers have been compensating for the defects in Taiwan's system of care. The Council of Labor Affairs once sought, in April 1998, to broaden the application of the Labor Standards Law to include domestic workers, but withdrew the proposal in January 1999. Without the protection of the Labor Standards Law, domestic workers do not have guarantees in working hours, sick leave, vacation, and other working conditions, nor do they have fixed job descriptions to follow. TIWA and Catholic immigrant worker groups have formed PAHSA

to propose enactment of the Household Service Act to protect the legal rights of domestic workers.

Taiwan's policies confine foreign blue-collar migrant workers to the position of "guest workers," who cannot stay permanently. Low-level foreign workers are merely supplement to the Taiwanese labor force and guests of this society. The legal controls of blue-collar migrant workers——the limitation of six-year work permits, not being allowed to change employers freely, and not being allowed to form labor unions——and the system of private brokers, which deepens the control of migrant workers through debt, make migrant workers silent when they confront the manipulating structures. The riot of Thai workers in Kaohsiung City showed that Taiwan's migrant worker policies had become a "New Slavery System." This system and the situation that domestic workers lack legal protection also led Taiwan to be included on the Tier-2 watch list in the US State Department's 2005 Trafficking in Persons report.

Executive Director of Scalabrini International Migrant Network-Taiwan /
Consultant of Taiwan International Workers Association

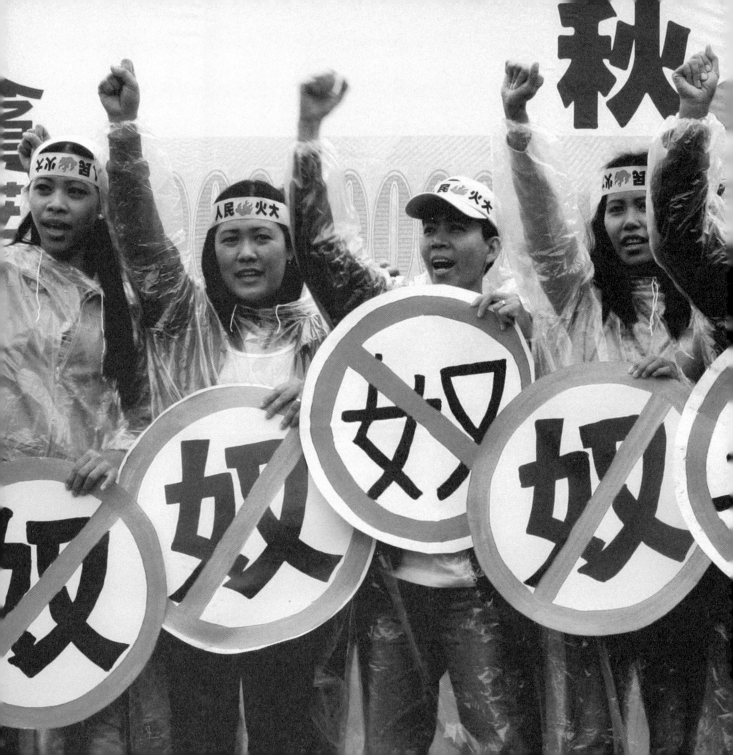

台灣國際勞工協會

　　1989年台灣開放引進移工，不論是在廠區或是在假日街頭，移工進入了台灣社會，創造了台灣人從未有過的勞動經驗及社會接觸。然而，勞動條件墊底的外籍勞工，在廉價勞動力的利益之下，成為台灣失業的代罪羔羊，在社會對待上也遭污名化與邊緣化，以經濟發展為主軸的台灣社會意識，並沒有公平地對待這一些來自東南亞經濟弱勢的勞動者；另一群以婚姻形式留在台灣的移工，即外籍配偶，因為異國文化、婚姻與家庭角色的期待，她們也面臨著同樣艱困的處境。

　　台灣國際勞工協會（Taiwan International Workers' Association）成立於1999年10月30日，是為全國第一個以外籍勞動者為服務對象的本地民間組織，關懷對象遍及外籍移工與外籍配偶。協會組成成員來自勞工團體、組織工作者以及工會幹部，除了發展本地勞動者與外籍移工的勞動經驗交流之外，也積極倡議移工權益，發展移工自治組織，近年來分別協助台灣印尼外勞協會（TIMWA）與菲律賓勞工協會（KASAPI）成立；同時有鑒於台灣社會充斥的種族隔閡意識形態，積極辦理文化活動，成立外勞樂團，轉化台灣社會對於外籍勞動者的認識，進而實踐尊重包容、公平的社會公義。自2002年起與相關移工團體共同組成「家事服務法聯盟」，推動家事服務工納入法律保障，倡議家事勞動者的勞動權益。

我們的宗旨

　　增進以婚姻或工作契約來台的移工，與本地社群之交流、改善移工及外籍配偶的勞動環境與社會處境、增進勞動階層的權益福祉為目標。

我們的服務

自助培力　發展組織：法律諮詢、勞資爭議協處、勞工教育、組織移工自助團體
文化交流　弱勢發聲：詩文/電影/歌舞交流、移工攝影與寫作、文化導覽、社區派對
政策辯論　行動倡議：國會遊說、抗爭遊行、國際串聯

台灣國際勞工協會（TIWA）

地址：台北市104中山區中山北路3段53-6號3樓
電話：886-2-2595-6858
傳真：886-2-2595-6755
Website: http://www.tiwa.org.tw/
E-mail: tiwa@tiwa.org.tw
劃撥帳號：19948580

Taiwan International Workers' Association

The main goals of TIWA (the Taiwan International Workers' Association) are to promote cooperation between migrant and local workers, to improve the working conditions and social environment for migrant workers in Taiwan, and to increase workers' rights and benefits. Taiwan began implementing a guest worker program in 1989. There are currently over 300,000 migrant workers in Taiwan, mostly from the Philippines, Thailand, Vietnam, and Indonesia. Not only have they contributed their labor, but they have become a unique part of Taiwan's vibrant society and cultural life.

Government policies, however, are both racist and classist, and disempower migrant workers in many ways. As cheap labor in Taiwan, migrant workers face the worst working conditions. They also face discrimination in Taiwanese society, where they are frequently made scapegoats for rising unemployment and any number of social problems. Aside from guest workers, there is also a rapidly increasing number of "foreign brides" —— women from the PRC and Southeast Asia who have married Taiwanese men. These women are also widely scapegoated in the Taiwanese media as the source of numerous "social problems," and face social isolation, barriers to citizenship rights, and discrimination in the workplace.

TIWA was established in October 30, 1999. It is the first local NGO in Taiwan to work for the rights of both foreign spouses and migrant workers. The members of TIWA are experienced labor activists and members of local unions. TIWA promotes communication between local and migrant workers and fights for migrants' rights. TIWA supports migrant workers' self-empowerment, including helping them to organize their own independent organizations such as the Taiwan Indonesian Workers' Association (TIMWA) and KaSaPi (a Filipino workers' organization). TIWA also fights the racism and classism within Taiwanese society by organizing cultural events such as music and dance concerts, cooking classes, poetry contests, and photo workshops, in order to challenge negative stereotypes of Southeast Asians in Taiwan.

Since 2002, TIWA has also been organizing a national wide network of migrant NGOs in Taiwan to form the Promoting Alliance for the Household Service Act (PAHSA). PAHSA is fighting for legal protection for domestic workers, who are not yet covered by the Labor Standards Law. In 2007, PAHSA changed name to Migrant Empowerment Network in Taiwan (MENT).

Taiwan International Workers' Association (TIWA)

Add: 3 Fl., No. 53-6, Sec 3, Zhong-Shan N. Rd., Taipei City 104, Taiwan
Tel: 886-2-2595-6858
Fax: 886-2-2595-6755
Website: http://www.tiwa.org.tw
E-mail: tiwa@tiwa.org.tw

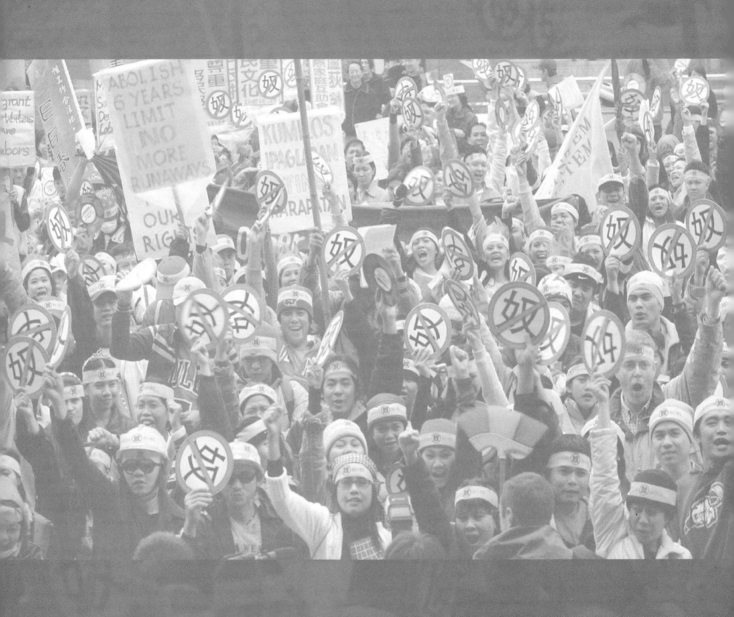

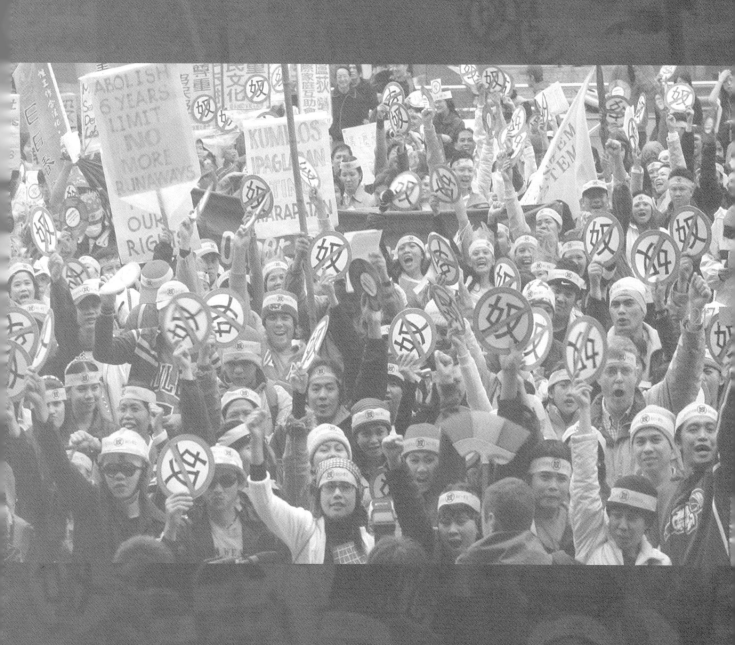

Canon 16

凝視驛鄉VOYAGE 15840 移工攝影集
Photographs by Migrant Worker

策　　劃	台灣國際勞工協會			
攝影工作坊苦力	吳靜如　江敬芳　陳慧如　許蕙如			
總 編 輯	吳靜如			
編輯委員	江敬芳　陳素香　顧玉玲　龔尤倩			
美術編輯	許英慧　江敬芳　張心寧			
翻　譯—英文	吳佳臻　徐睿楷　曾涵生　張秉瑩　司黛蕊			
—中文	江敬芳　曾涵生　張秉瑩　陳秀蓮　郭耀中　黃于玲　王品			
	王維菁　謝采秀　黃寶儀　王君綺　鄭育萍　Jennifer Lai　Yen-ling Chen			
—印文	譚雲福			
—越文	阮文雄神父　梅鶯			

發 行 人	張書銘
出　　版	**INK**印刻文學生活雜誌出版有限公司
	台北縣中和市中正路800號13樓之3
	電話：02-22281626
	傳真：02-22281598
	e-mail：ink.book@msa.hinet.net
網　　址	舒讀網http：//www.sudu.cc
法律顧問	漢廷法律事務所
	劉大正律師

總 經 銷	展智文化事業股份有限公司
	電話：02-22533362・22535856
	傳真：02-22518350
郵政劃撥	19000691　成陽出版股份有限公司
印　　刷	海王印刷事業股份有限公司

出版日期	2008年 3月 二版一刷
定　　價	350元
ISBN	978-986-6873-65-2

國家圖書館出版品預行編目資料

凝視驛鄉VOYAGE15840：移工攝影集
　　／吳靜如等編輯；吳佳臻等翻譯.
--初版，--台北縣中和市：INK印刻，2008.3
　　面；　　公分. --（canon；16）
ISBN　978-986-6873-65-2　（平裝）

1.攝影集　2.外籍勞工

957.9　　　　　　96026068

凝視驛鄉VOYAGE 15840 移工攝影集
Photographs by Migrant Worker

Proposer	Taiwan Internationl Workers' Association
Photo Workshop Coolies	Wu Jing-Ru, Chiang Ching-Fang, Ellen Chen, Tracy Hsu
General Editor	Wu Jing-Ru
Editors	Chiang Ching-Fang, Susan Chen, Ku Yu-Ling, Lorna Kung
Art Editors	Hsu Ying-Hui, Chiang Ching-Fang, Chang Hsing-Ning
Translators	English-Wu Ji-Zhen, Eric Scheihagen, Tseng Han-Sheng, Chang Ping-Yin, Teri Silvio
	Chinese-Chiang Ching-Fang, Tseng Han-Sheng, Chang Ping-Yin, Chen Xiu-Lian, Guo Yao-Zhong, Huang Yu-Ling, Wang Pin, Wang Wei-Jing, Xie Cai-Xiu, Huang Bau-Yi, Wang Jun-Qi, Cheng Yu-Pin, Jennifer Lai, Yen-ling Chen
	Indonesian-Tony Thamsir
	Vietnamese-Fr. Peter Nguyen Van Hung, Mai Loan

Publisher	Chang Shu Min
	INK Publishing Co., Ltd.
	13F-3, No.800, Jungjeng Rd., Junghe City, Taipei, Taiwan 235, R.O.C.
	Tel：02-22281626
	Fax：02-22281598
	e-mail：ink.book@msa.hinet.net
Webisite	http://www.sudu.cc
Legal Adviser	Han Ting Law Group
	Liou Da Jheng

Agent	Zhan Zhi Culture Co., Ltd
	Tel：02-2253336·22535856
	Fax：02-22518350
Taiwan Post Account No.	19000691 Rising Sun Publishing Co., Ltd.
Printer	Hai Wong Printing Co., Ltd.

Published Date	March 2008
NT	350
ISBN	978-986-6873-65-2
Printed in Taiwan	

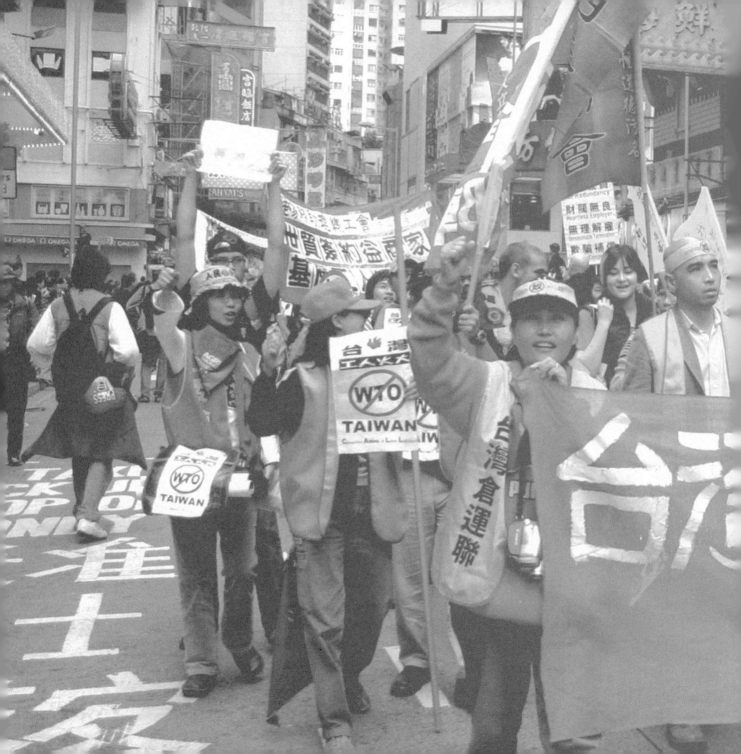